San Francisco Love Affair
a photographic romance

Gene Wright *Images* 1949 – 2000

First Published 2006

Individual photographs copyright © 2006 Gene Wright Art Works
www.genewrightart.com

ISBN# 0-9762747-7-9
Library of Congress control number: 2006930900

Book and cover design by Whitney McAtee
Art direction by Jay Blakesberg
All high-resolution scanning and digital file preparation by Paul Halmos
www.paulhalmos.com

Printed in China

Published by Rock Out Books
P.O.Box 460054
San Francisco, California 94146
415-621-2366
www.rockoutbooks.com
email: info@rockoutbooks.com

Distributed by SCB Distributors
15608 S. New Century Drive
Gardena, California 90248
310-532-9400
www.scbdistributors.com

Limited Edition fine art prints from the estate of Gene Wright are available
for purchase. Please contact info@rockoutbooks.com for more information.

Rock Out Books

Grant and Green
A foreword by Aaron Peskin

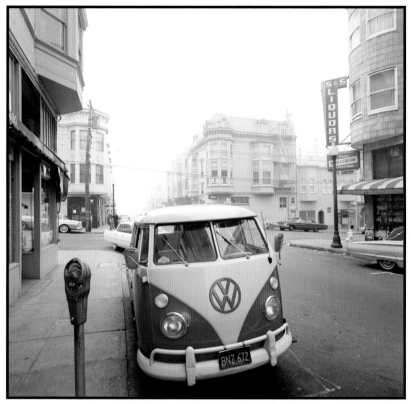

Gene's VW at Grant and Green, North Beach

Few people have shaped the way we see San Francisco as Gene Wright did through the lens of his camera. Gene's black-and-white photography captured not only the architectural landmarks that have become icons of this great city, but the human essence that gave them life. From vibrant North Beach cafés to the view from an airplane flying high above the San Francisco Bay, he depicted the magical character of San Francisco like no one else. Gene did for the City by the Bay what Ansel Adams did for California's natural landscape: by showing us how he saw it, he made it iconic.

It takes a unique vision to capture the spirit of a city on film. You have to live it. In fifty years as a fixture of the City's arts community and the North Beach neighborhood, Gene Wright did just that. He lived with the same openness of heart and liveliness of spirit that he captured in his images, welcoming any willing passerby into his Grant Avenue studio to converse about art and the city he loved.

I was very lucky to have had the chance to get to know Gene before he passed away, and I had the pleasure of honoring him when the Board of Supervisors declared him a San Francisco Living Legend in 2002. I will always remember him sipping his chilled vodka with an olive, just as the world will always remember San Francisco in the 20th Century through his lens. In a city known for its creativity, Gene was a renaissance artist. The body of work shown in these pages is a fitting tribute.

Gene Wright's photography came of age just as the community of Beat poets was coming to life in North Beach. As a result, the photographs he left behind offer an intimate portrait of San Francisco through one of its most distinctive and exciting eras. His work provides us with a crucial window into our city's romantic past, and his vision will forever be part of the history of San Francisco.

Aaron Peskin
President – San Francisco Board of Supervisors
June 2006

San Francisco Love Affair
Introduction by Andy Tennille

If a picture truly is worth a thousand words, then Gene Wright has written more words about San Francisco than anyone.

Be it his cityscapes capturing the towering office buildings in the Financial District, his series of the city's trademark streetcars, the brilliant portraits of Coit Tower or the vast panoramic images of the Golden Gate Bridge, Gene's enduring passion for San Francisco is as clear as the black and white medium he chose to express his vision. A licensed pilot, published writer and poet, accomplished musician and debonair gentleman, Gene Wright was a renaissance man whose limitless talents were surpassed only by his innovation as a photographer and his love affair with the city that was his home for more than 50 years.

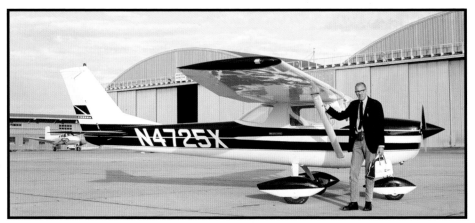

Eugene Vernal Wright always considered himself a native San Franciscan. Although he was born in Ogden, Utah in April 1916, Gene felt a strong kinship with the city, an affinity inherited from his parents, George and Loretta. The couple married in Utah and came to San Francisco on their honeymoon in 1915. Gene was conceived on the trip, but Loretta decided shortly before her due date to return to her mother in Utah for the birth. As a youth in Ogden, Gene showed a propensity for the arts, occasionally performing original songs and writing jingles for a local radio show. He wanted to be a songwriter and musician; but by the sixth grade, Gene was skipping school regularly and spending his lunch money at the movies. He became enamored of the lighting effects used on actor's faces, hair and clothes. The black and white images made a lasting impression.

Gene's first forays into photography coincided with another of his many passions – aviation. As a teenager, Gene worked at the local airstrip in Ogden, cleaning planes and clearing the runway of debris. One afternoon, he met Hollywood star Wallace Beery when the actor

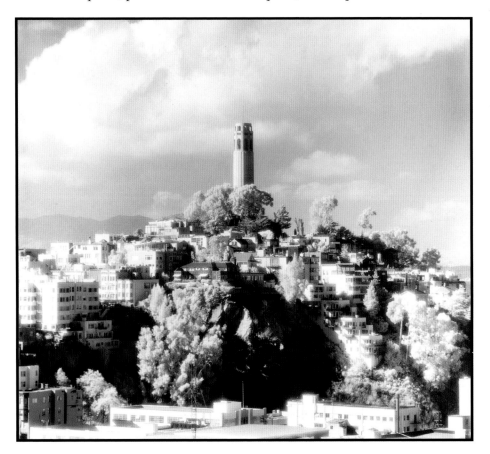

flew into town to visit a girlfriend. In return for cleaning his plane, Beery took the aspiring pilot for his first flight and over the next few months taught Gene to fly. By that point, Gene had bought a camera to try and capture the images that he saw in his mind. On his first solo flight in Beery's plane, Gene took his new camera in hopes of taking a few pictures. Knowing he was going to be up for only five or ten minutes, he flew over a pasture where the owner of the local brewery had horses.

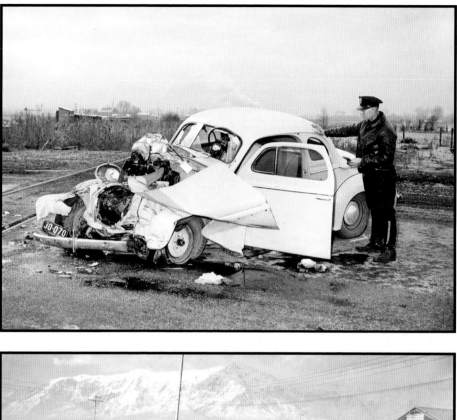

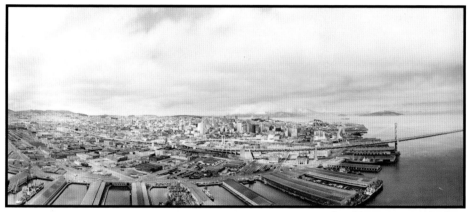

San Francisco aerial, 1960s

The owner's favorite white mare was in the pasture, so Gene flew low, put the plane in a holding pattern and snapped several pictures. Gene raced home to develop the film and print the image. As he was moving the print around in the developing tray, Gene shook with anticipation. The image of the white horse finally appeared and Gene was amazed. He mounted the photograph and took it to the brewery. On the spot, the owner offered him $50.00 for the picture, a small fortune during the Great Depression. From that point on, Gene knew he had a special talent as a photographer and was determined to develop it. As a staff photographer for the *Ogden Standard Examiner* and a contributing photographer for the *Salt Lake Tribune, The Deseret News,* and *Golf and Travel* magazine in the late 1930s through the mid-1940s, Gene honed his skills and developed his craft, photographing everything from car accidents and murder scenes to golf courses and political events, including a visit to Ogden

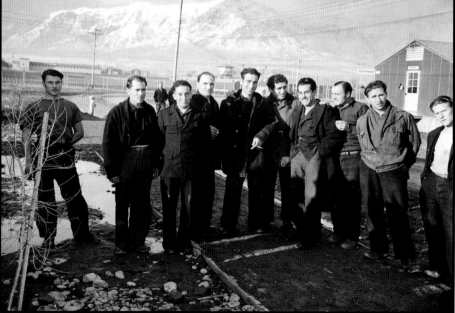

WWII POWs in Utah

by eventual President Harry S. Truman. As America entered World War II, Gene served his country photographing prisoners of war held in Utah for the War Department to assure foreign governments that their countrymen were not being mistreated, but it was the side business that Gene ran out of his studio on Washington Boulevard through which many enlisted men became aware of his work.

During the war, women wanted to send Betty Grable-type pictures to their sweethearts and husbands in Europe or the South Pacific. Gene charged 50 cents a sitting, provided lipstick and sometimes even helped with hairstyling. He had two swimsuits to choose from; if one didn't fit, perhaps the other one would. Through his portrait business, Gene became an expert in lighting techniques and posing subjects.

After making several trips to San Francisco with his mother's encouragement, Gene finally moved to the Bay Area in 1949 and took a job as a photographer for the Southern Pacific Railroad Company. Within two years, Gene grew tired of the monotony of the job and wanted to pursue the artistic side of his photography full time.

"It was then that Gene began going out on walks around San Francisco and taking pictures just to see what he came up with," said Liz Wright, Gene's wife of nearly 35 years. "He usually took an old leather journal that had a pad of paper and pen. If Gene saw something he thought would make a good picture, he'd jot down a little note about the picture and how it should be taken. And then he'd wait for the right light or clouds. Sometimes he'd wait until the fog came in. He was very precise with his vision. If something didn't turn out in the dark room just as he imagined it, he'd toss it. Gene always said the wastepaper basket was the guardian of his reputation."

As Gene began to explore artistic photography, his interest in wide-angle photographs grew. Despite shooting with standard-view cameras at the time, Gene would crop his pictures into panoramic format. By the time Gene was discovering wide-field photography in the late 1940s, panoramic cameras had been around for more than a hundred years. In 1843, Austrian Joseph Puchberger developed a camera featuring a hand crank-driven swing lens that could capture photos in a 150-degree arc using an 8-inch focal length camera with Daguerreotype plates 24 inches in length. The next year, Germany's Friedrich von Martens patented the Megaskop, his own panoramic camera which utilized a set of gears to improve the camera's panning speed and improved the overall picture quality.

In the early 1950s, Gene received his first panoramic camera from Panon Camera Company, a Japanese manufacturer that had heard about Gene's pictures through friend and fellow photographer Simon Nathan. Panon approached Gene and asked him to try out the $500 camera. The swing lens, revolving slit Panon Wide Angle Camera made a 140 degree 2" x 4.5" picture on standard 120 roll film.

Shooting with panoramic cameras in a professional setting was unique and cutting-edge, but Gene had the type of mind that could think in 140 degrees. One early example of his innovation using the Panon is possibly his most famous photo. In 1955, Gene took a series of pictures of the cable cars along California Street. For *Cablecar Tracks* (p.38), Gene positioned himself at the bottom of the hill with

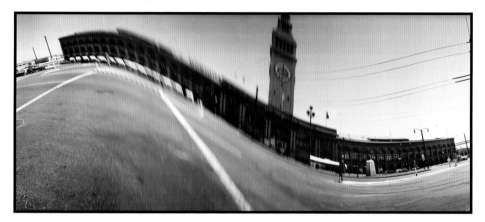

the camera. He positioned the lens at the top and shot all the way down to where he stood. The panoramic perspective, coupled with the location of the camera, gives the impression that the tracks are curved. Ten years after he took it, the photograph was named one

of the best pictures internationally in the *1965 Popular Photography Annual*. "Most of the panoramic cameras were used for group pictures, for banquets or for more conservative commercial photography, but Gene took it beyond that dimension," said John Larish, a former executive at Kodak who met Gene in 1968. "He took it into the world of the art image. He had a keen photographer's eye. You hear that about the Ansel Adamses and Richard Avedons of the world, that they've got the eye. Gene had that eye. I saw it the first time I walked into his studio in North Beach."

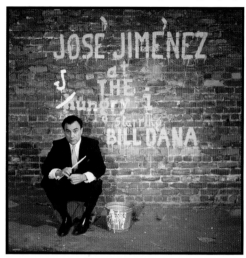

"Gene Wright, Photographer," the studio Gene opened at 1412 Grant Avenue in 1951, was located in San Francisco's North Beach neighborhood, the epicenter of the city's budding beatnik movement in the '50s and '60s and a cross-continental cultural counterpart to New York City's Greenwich Village. "It was such an amazing place

360° panoramic of Gene in his North Beach studio

on Grant Avenue. It was the city's Bohemian district, so it was like there was art in the air," said Anne Auburn, who first met Gene in the late '60s. "There was live music everywhere you went. The coffee houses were right down the street where all the poets used to hang out. Lawrence Ferlinghetti's City Lights Bookstore was just around the corner down Columbus. The whole neighborhood was rich in history and it was a big hangout. Everyone knew one another. San Francisco was really amazing at that time and Gene's quirky energy blended beautifully with the bohemian subculture that had blossomed in the neighborhood. Gene's love for the city was like for a woman," she added. "He really saw the feminine in San Francisco.

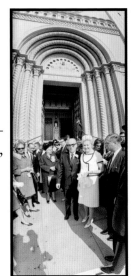

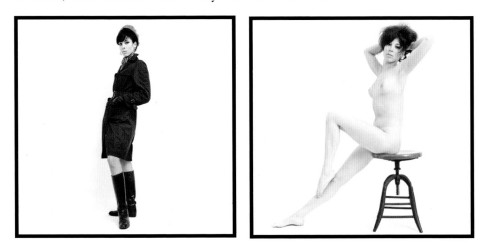

It was as though she was an elegantly-dressed woman. And he was always dressed elegantly himself, in all black and most of the time with an ascot and beret. He was a gentleman more than anything else – it came effortlessly to him."

More than thirty years older than the emerging flower children of the 1960s, Gene shared their youthful exuberance but also embodied the gentility and artistic sensibilities of the Beats. "People loved coming into the studio because of the beautiful photography, but often remained for hours," Liz said. "He'd offer them a glass of wine or an espresso or a vodka martini. Gene was a gracious, entertaining host and people enjoyed dropping in for visits." With a studio

in place in busy North Beach, Gene maintained a steady freelance career consisting of commercial assignments for radio stations, construction companies, developers, corporations, and non-profits, as well as photographing weddings and family portraits. Many aspiring fashion models came to Gene's studio during this time in search of hip images for their portfolios, and in a sign of the times, nearly all of them wanted nude images to include in their portfolios. One regular commercial client was the United Way in San Francisco. In 1963, the agency needed a photo for a fundraising drive for St. Mary's Help Hospital. As he toured the hospital, Gene saw a mother and child and asked his escort, hospital administrator Sister Elizabeth Marie Mee, if she would hold the baby. Gene quickly snapped the young nun gazing tenderly at the wide-eyed infant resting in her arms. Gene's *Mercy Madonna* (p.74) won first prize in the United Community Funds and Councils of America National Photography Contest, ran in the San Francisco Examiner and was picked up by the Associated Press. Marsha Goodwin, a close friend of Gene's, believes *Mercy Madonna* is a perfect example of Gene's ability to capture not only an image, but also its essence.

"I think Gene's sense of fairness was truly unique," Goodwin said, "in an ideal world, we want things to be fair and then we realize that they're not. I think he was very good at picking up on what would make the viewer think of things that weren't fair. I'm particularly thinking about *Mercy Madonna*. Gene evoked that emotion with great elegance and yet he still brought the same message home. It's almost as if he wanted you to see the great beauty first and then the message would just hit you."

"Gene's most famous for his panoramic images of San Francisco, but some of my favorite photos of his are the ones with people in them," said Christine Haas, a long-time friend and patron. "My favorite

is a picture of five men looking at a Christmas tree from outside of a window that he took in 1953 (p.76). The expressions on each individual's face – there's one man with hope and another who's completely lost hope – speak volumes. Gene was really great at capturing the panorama of human emotion. There's also *The Barbershop* in North Beach (p.24) that he photographed. Take a look at each individual's expression in this photograph. He just had this uncanny ability to capture that pure, organic moment and the emotion of each person."

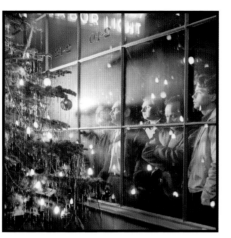

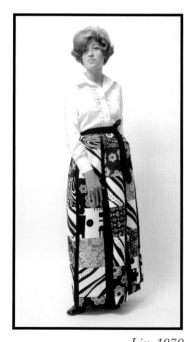

Liz, 1970

One possible explanation for Gene's ability to capture the essence of human emotion may have been rooted in his own search for true love. He found it in March 1970 when he met Mary Elizabeth Anderson. In February 1971, after nearly a year of courtship, the couple married. "I always joked with Liz that Gene's first love was for Liz and the second was San Francisco," Auburn said with a smile. "Liz was like the wife and San Francisco the mistress, and it was like that for their entire life together. Gene once told me that you could line up the most beautiful women in San Francisco in one room and he'd always pick Liz. Their relationship was incredible and filled with so much love."

Within a year of their wedding, Liz convinced Gene to open a gallery to sell his fine art photography so he could work in the Grant Avenue studio without worrying about the retail business. They opened a small gallery in a prime location at The Cannery and another a few years later in Carmel. "We'd have hundreds of people through the gallery every day because, at that time, The Cannery and Ghirardelli Square were the only two tourist spots down at Fisherman's Wharf," Liz remembers. "We ran out of prints constantly. Gene would print 100 pictures of the *Foggy Bridge* and bring them down on Friday evening. By Sunday, they were gone. And that's just one image. We had to work around the clock. Gene would never let anyone print his negatives. He always did everything himself."

In 1973, Gene got his second panoramic camera, a Cyclopan capable of taking 360-degree photos. "Not long after he got that camera, I was at their apartment for dinner one night having cocktails and I asked to use their restroom," said Tom Hunger, a great friend and customer of Gene's. "Gene pointed me down the hall. I walk into the bathroom and can't believe my eyes. He'd mounted a panoramic picture of the *Underside of the Golden Gate Bridge* (p.38) on the inside of a curved piece of wallboard and hung it behind the toilet. When you sat down, you looked straight up at the underside of the bridge right over your head. It was the craziest view." Besides employing

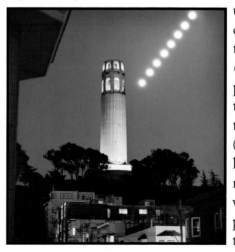

unique camera angles, Gene also did longer exposure compositions such as *Eight Moons Over Coit Tower* (p.34) and even experimented with moving both the camera and the subject while the panoramic lens was in motion (p.42). A true innovator, Gene's limitless imagination and willingness to try anything to execute his vision were matched only by his precise skill and his willingness to take risks as an artist.

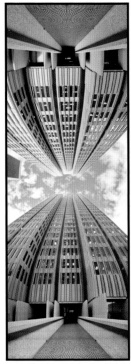
Embarcadero buildings

"I've got one in my den, it's a black and white that he did of the Embarcadero Center buildings" (p. 41), said Ed Haynes, a friend of Gene's since the mid '70s. "Gene set his tripod up in the middle of the two buildings and shot up the height of one of the buildings and then across the sky and down the other building to the ground again. People that don't know Gene and don't know San Francisco think it's the same building doubled over, so I have to point out to them that it's two different buildings. The only way you can tell they're two different buildings is because the lights from inside the building aren't the same on both. It's just an increible picture and really speaks to how innovative Gene was with that 360-degree camera."

By 1979, tired of producing hundreds of prints a week to supply two successful galleries, the couple retired. "We took a full year off," Liz said with a laugh. "That's how long our retirement lasted. Then we moved back and got a place right next door to where he had been on Grant Avenue." By a proclamation in February 2002, the San Francisco Board of Supervisors declared Gene "a living legend" for his "outstanding artistic accomplishments, his tireless contribution to making San Francisco a haven for artists and his status as a world-renowned San Francisco photographer and artist." This wasn't the first time city officials had honored Gene. In 1963, San Francisco Mayor George Christopher awarded Gene a key to the city in acknowledgement of his history in North Beach and accolades as a prestigious photographer. Supervisor Aaron Peskin, who represented the North Beach neighborhood where Gene's studio was located, presented Gene with his Living Legend Award, calling him "a quintessential San Franciscan and a remarkable photographer. His images of the city really embodied why San Francisco is such a special place."

"Nobody else saw San Francisco like Gene did," said Jane Scott, a corporate art dealer based in Palm Springs and a close friend who worked in The Cannery gallery in the late '70s. "I mean, it's sort of like Ansel Adams and Half Dome. There are a million pictures of Half Dome but what's the one you remember? You remember *Moon Over Half Dome* and you will for the rest of your life. No one will ever be able to replace that image for you. There are a million people that have taken pictures of Coit Tower or the Transamerica Pyramid or any of those cable cars, but Gene always gave it a novel spin. He just treated them completely differently. His work was a 10 on a scale of 1 to 10. He was always operating at 10. And he got that result almost every time."

In December 2004, Gene passed away after a long battle with congestive heart failure. He was 88 years old.

"Photography is the recording of moments. That's what Gene had - that uncanny ability of perfectly recording a moment," John Larish said. "Gene had a gift of being able to capture a moment on film in a way that was timeless. The images he did over and over again were images that have a lasting quality about them. Certainly, it's easier to do some of those things today digitally, but Gene took the moment and captured it perfectly without any of that. You didn't get a second chance with the equipment that he was using. He was a master of the moment."

"He was really a San Franciscan, and he loved San Francisco like no one in the world loved this city," Liz said. "His photography is a true expression of how beautiful it was to him. Everything about it was very important to him. He was just totally enamored of it. It was truly a San Francisco love affair."

"These images saved will come alive in the following pages."
- Gene Wright

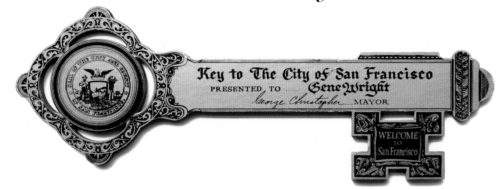

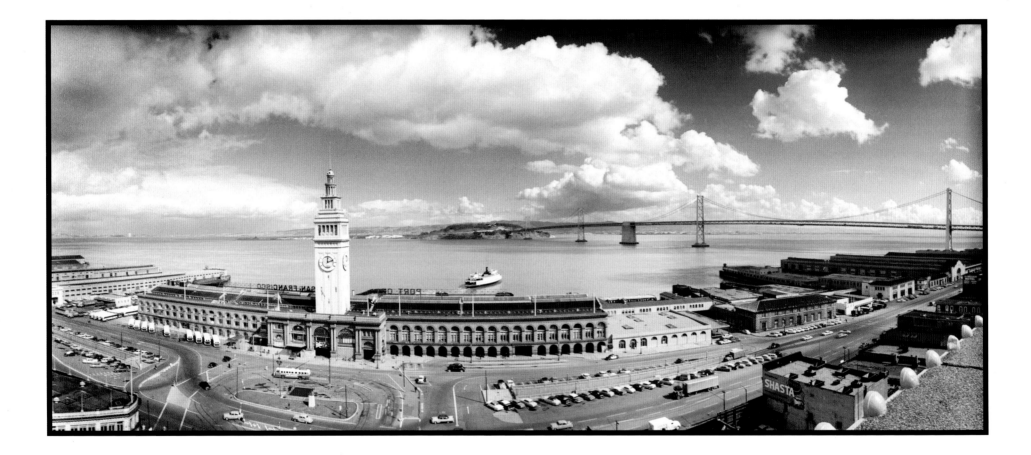

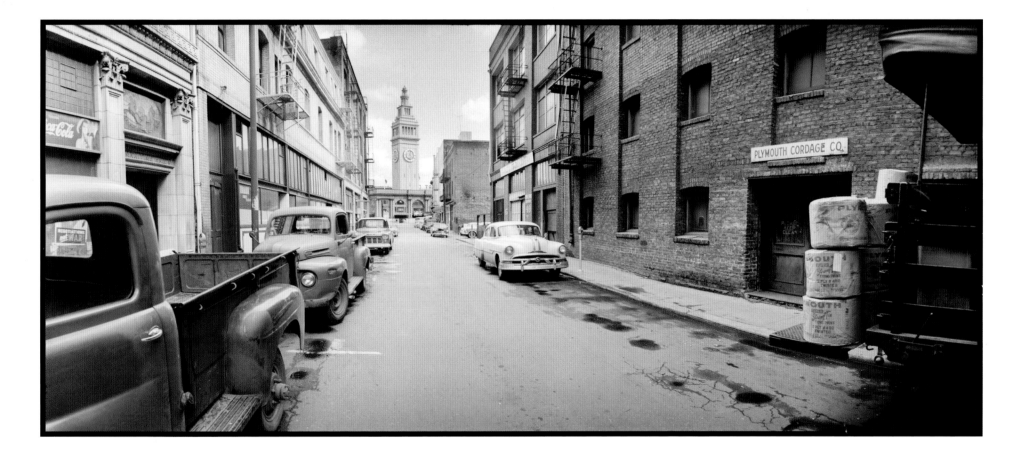

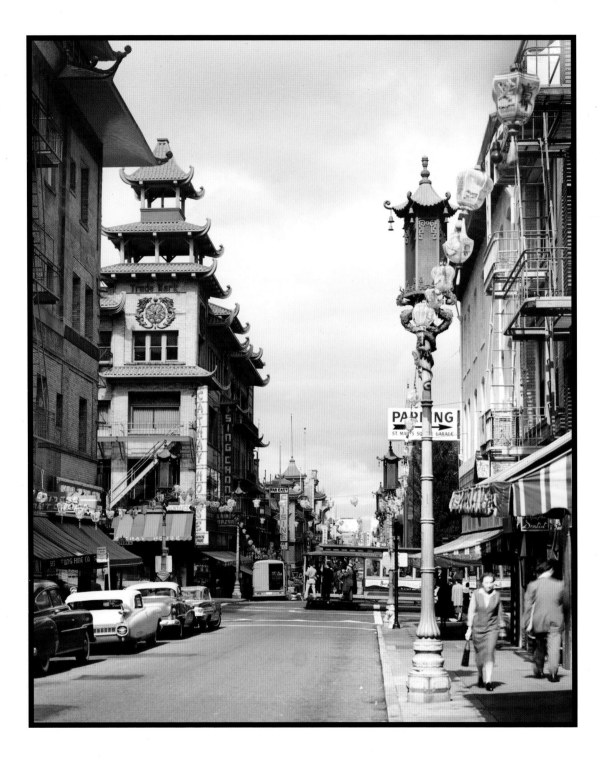

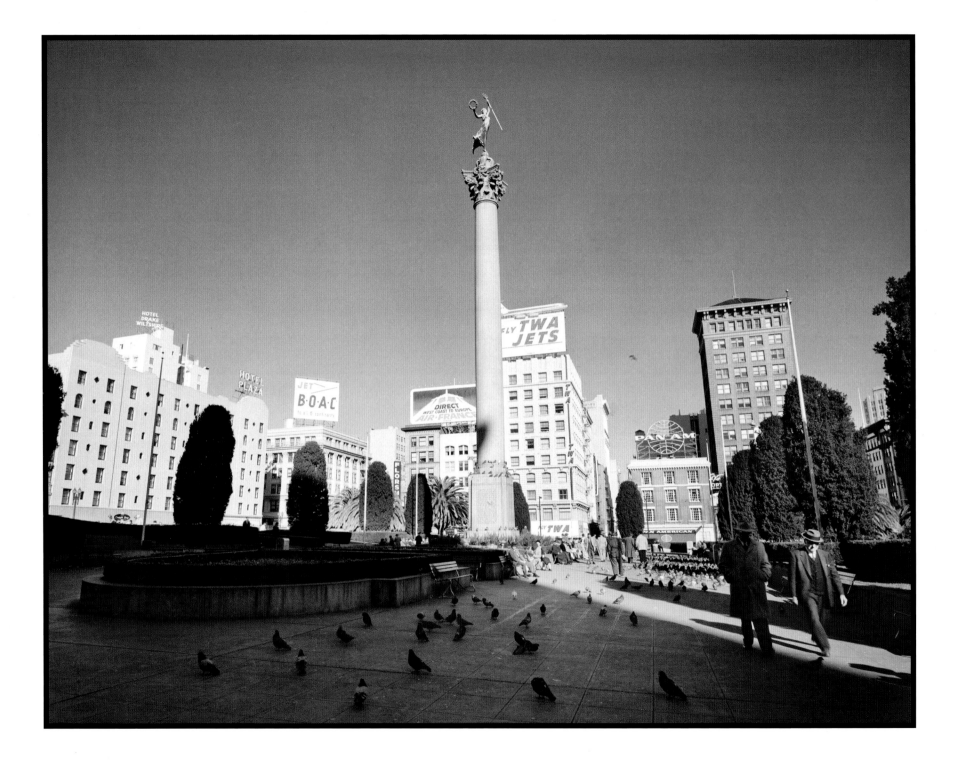

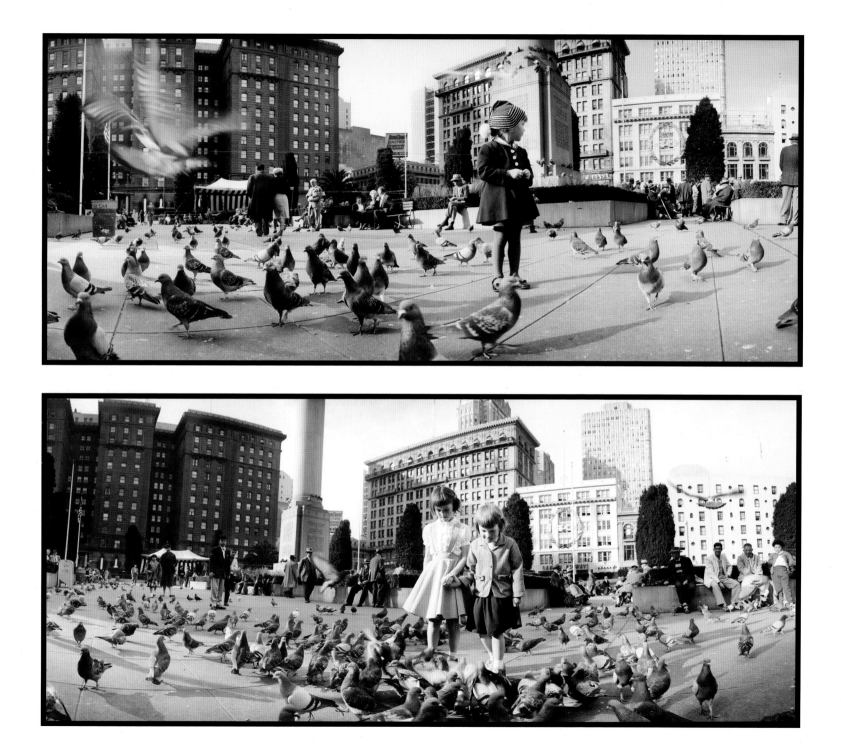

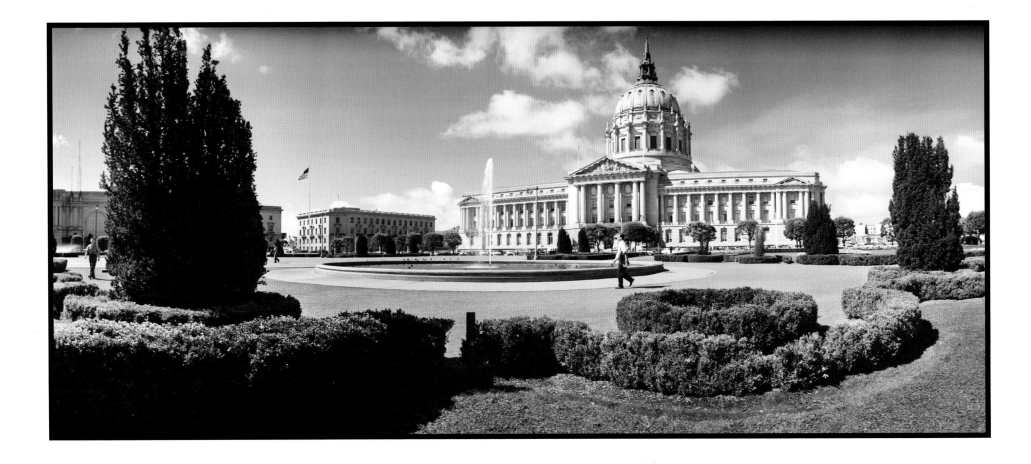

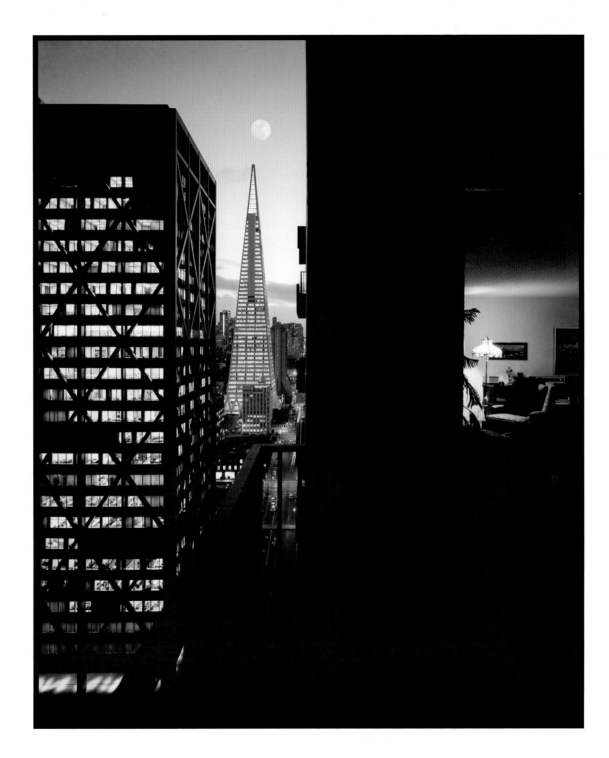

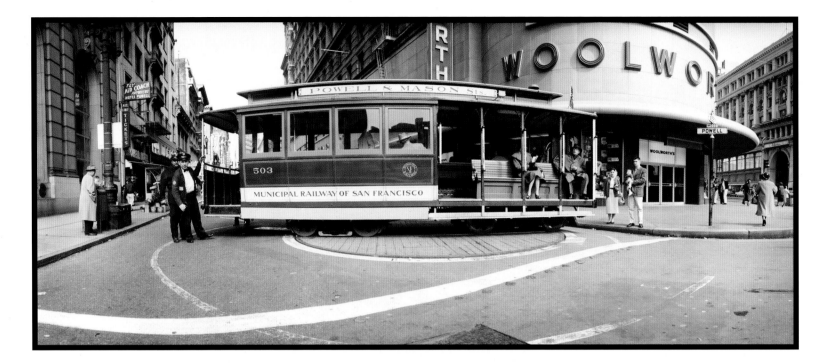

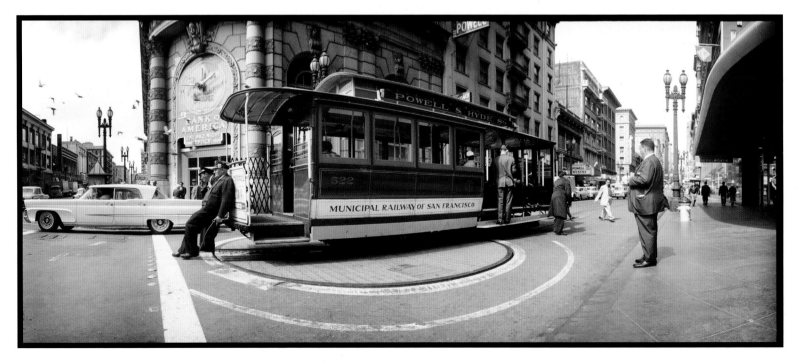

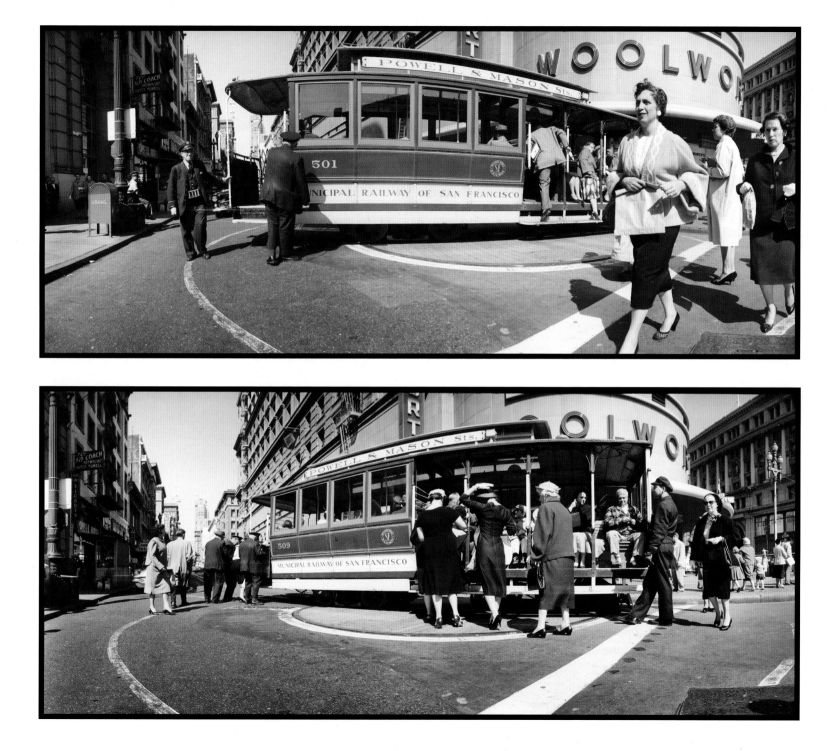

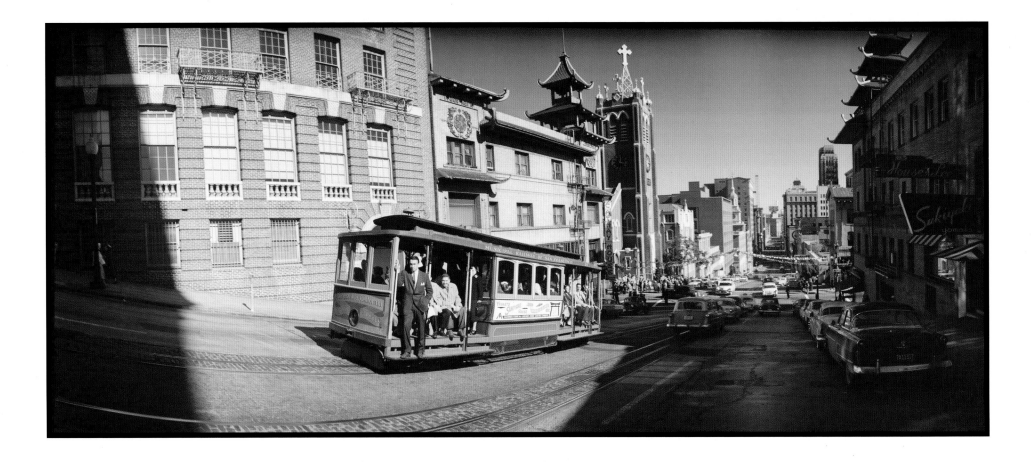

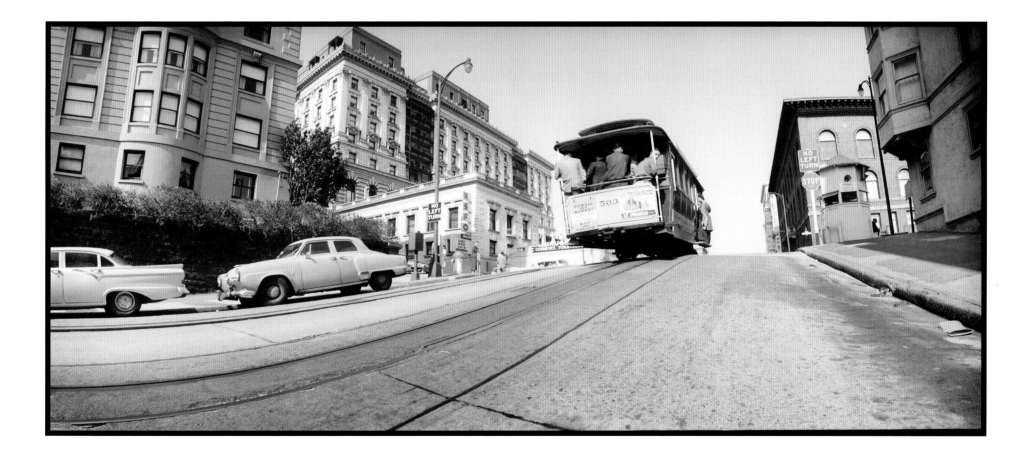

23

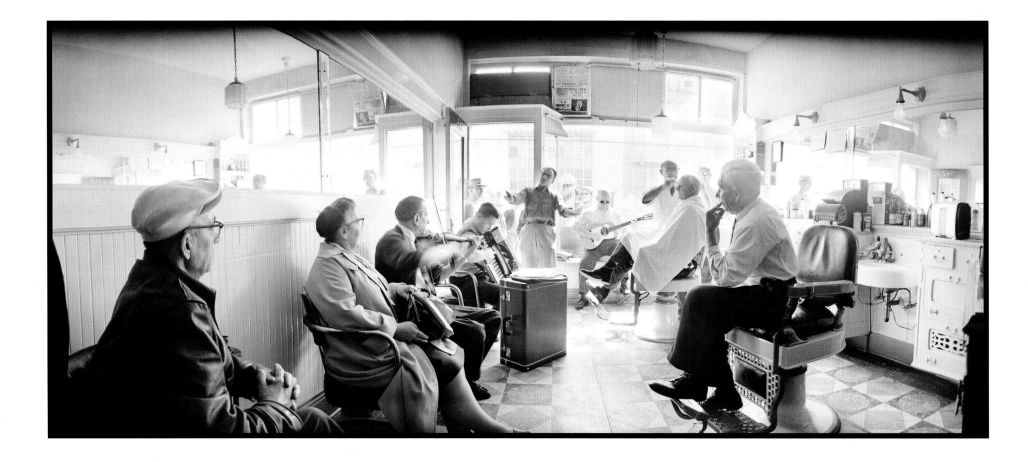

24

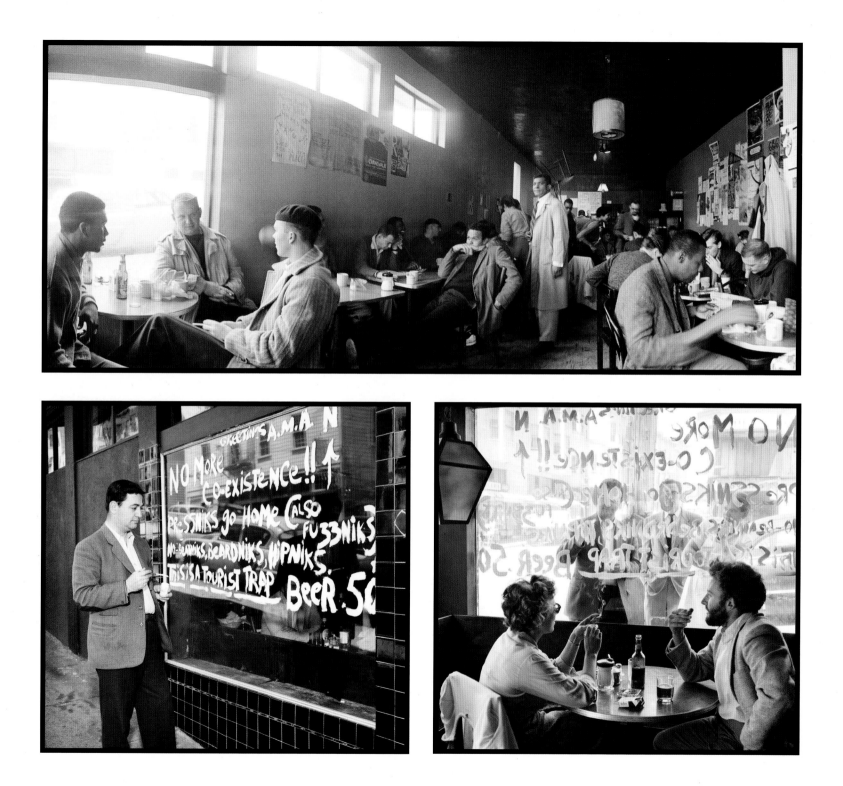

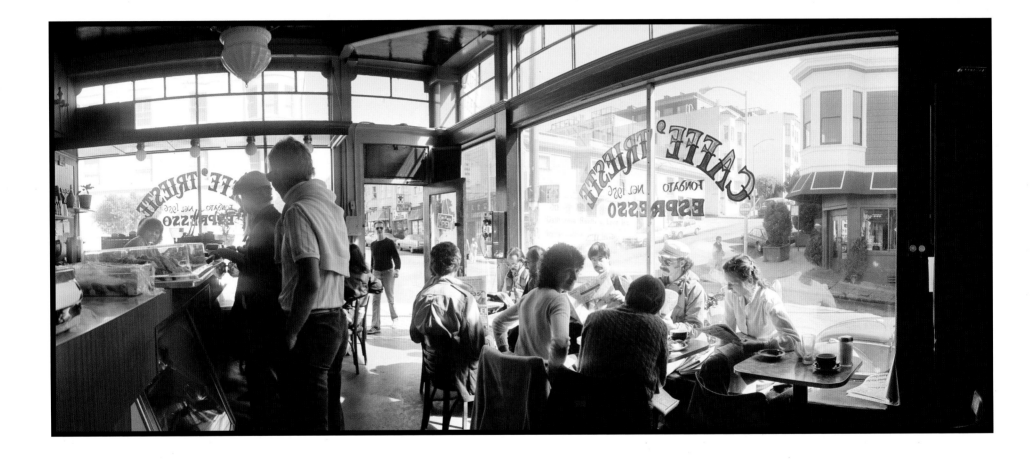

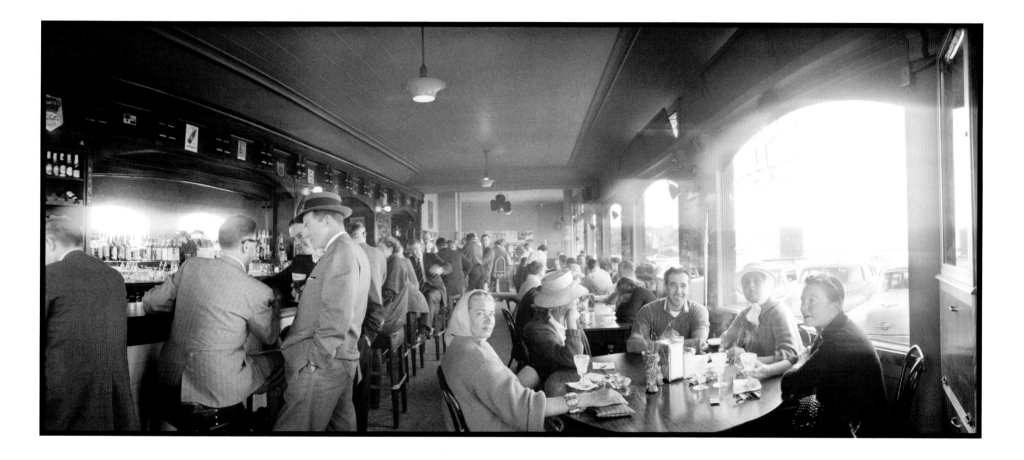

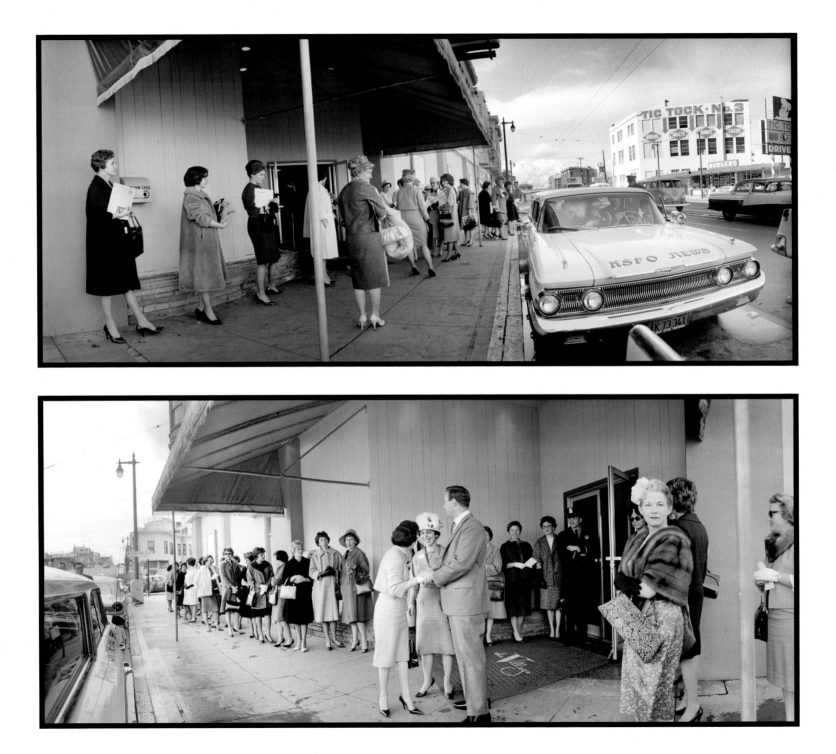

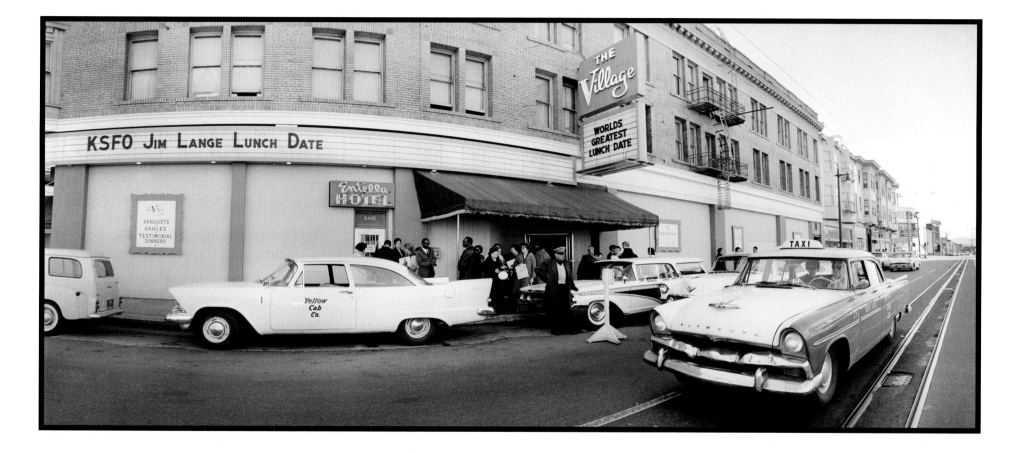

29

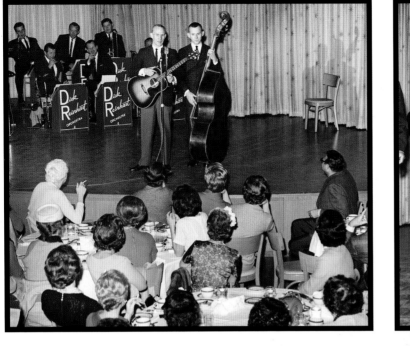

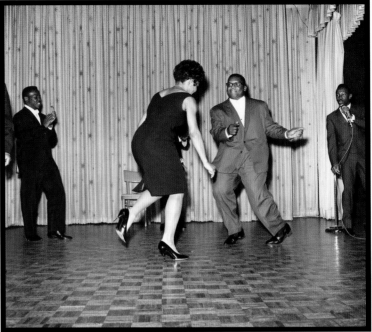

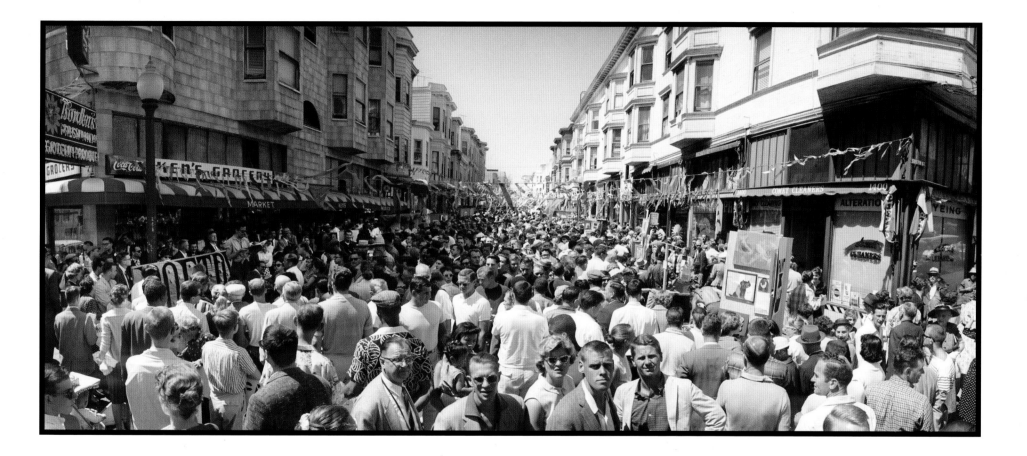

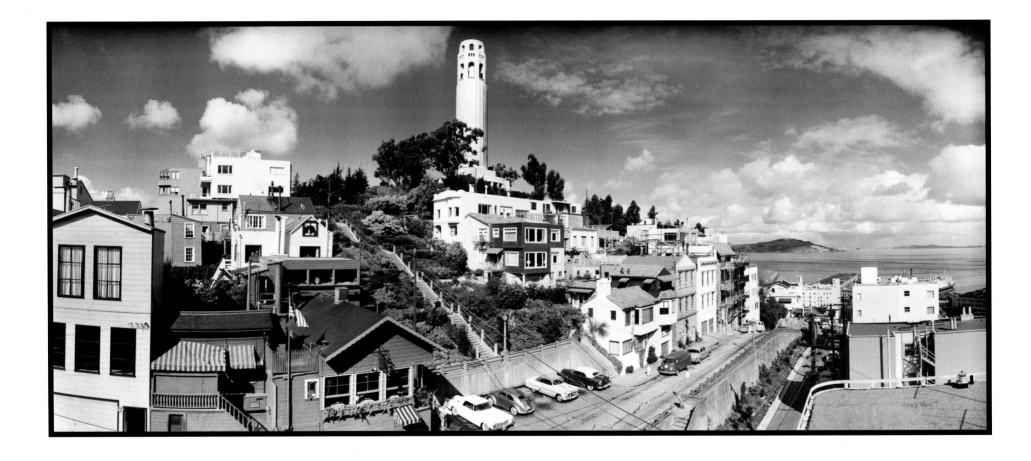

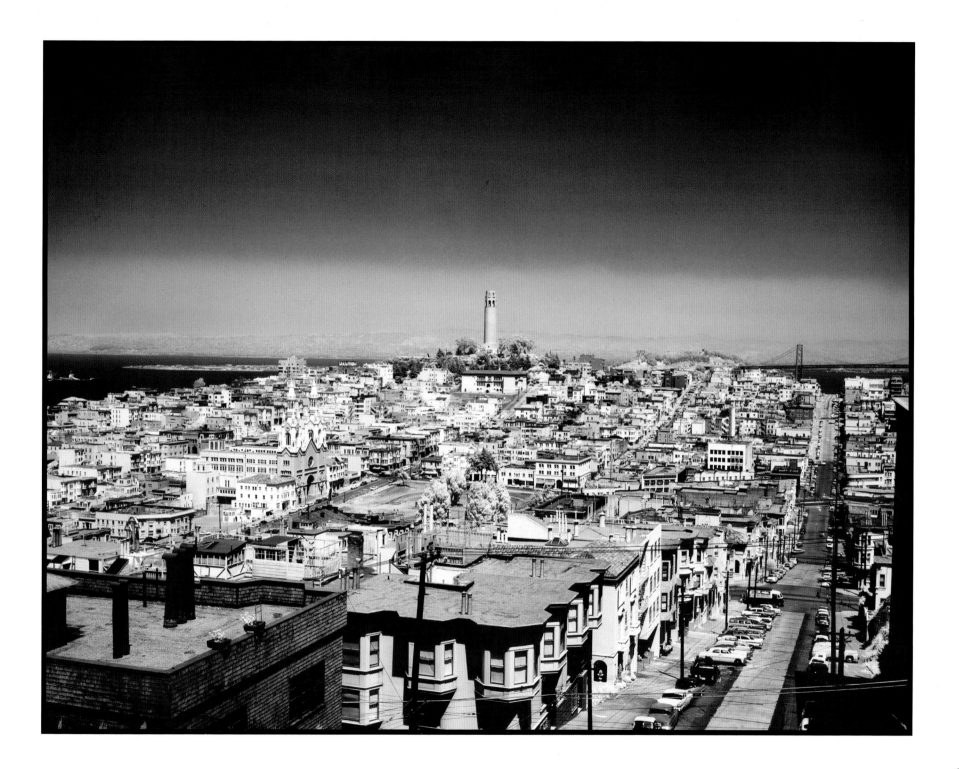

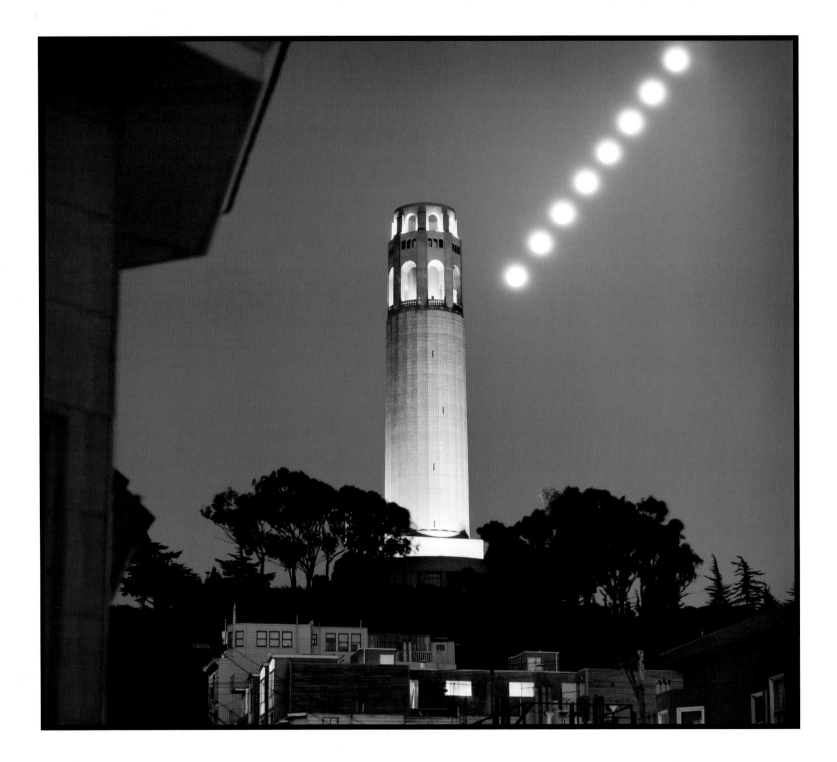

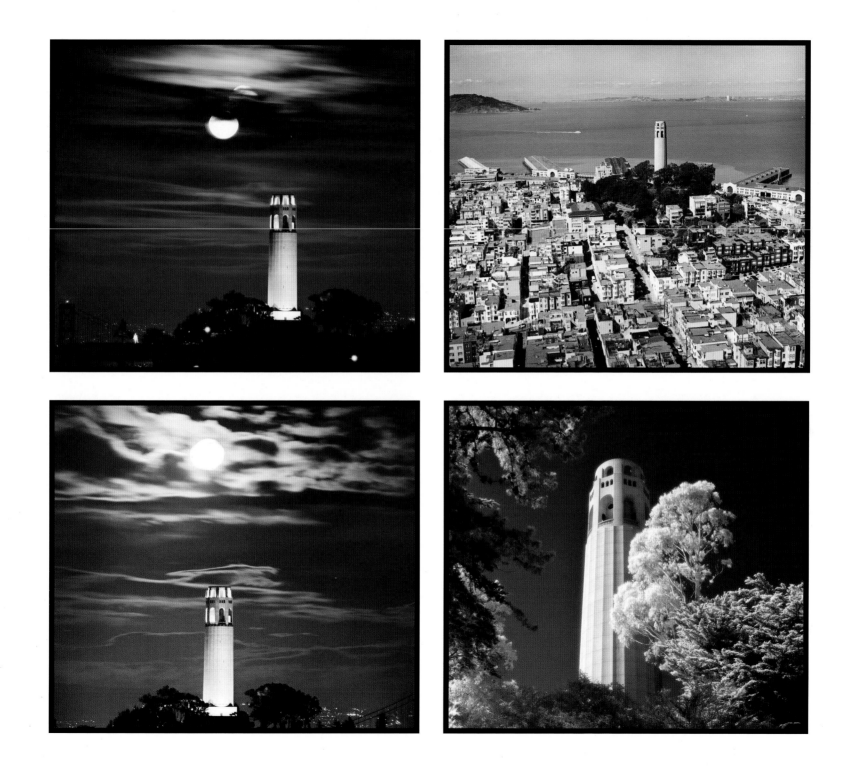

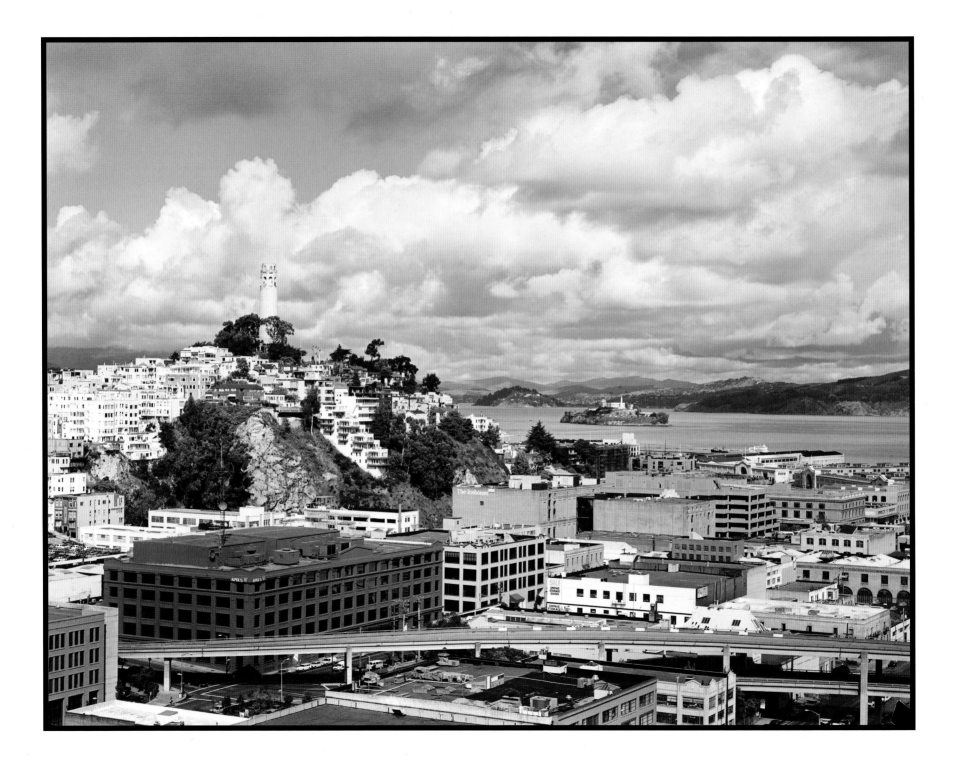

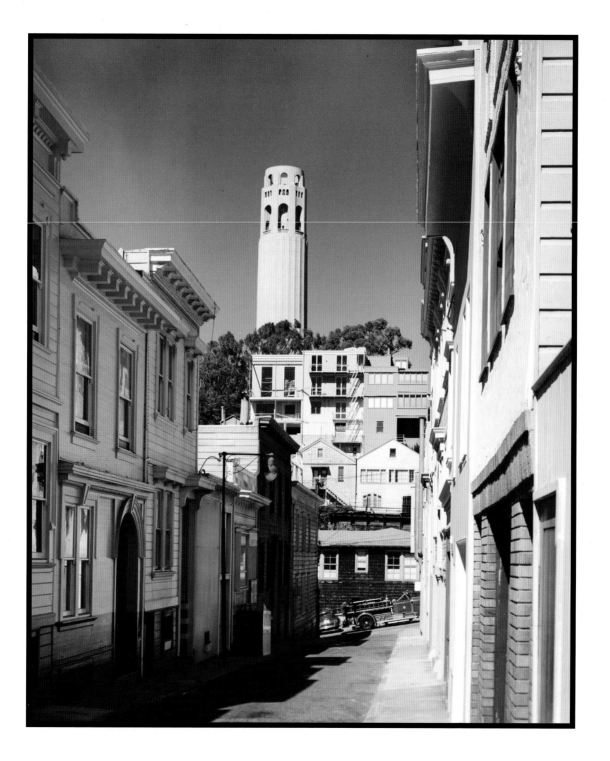

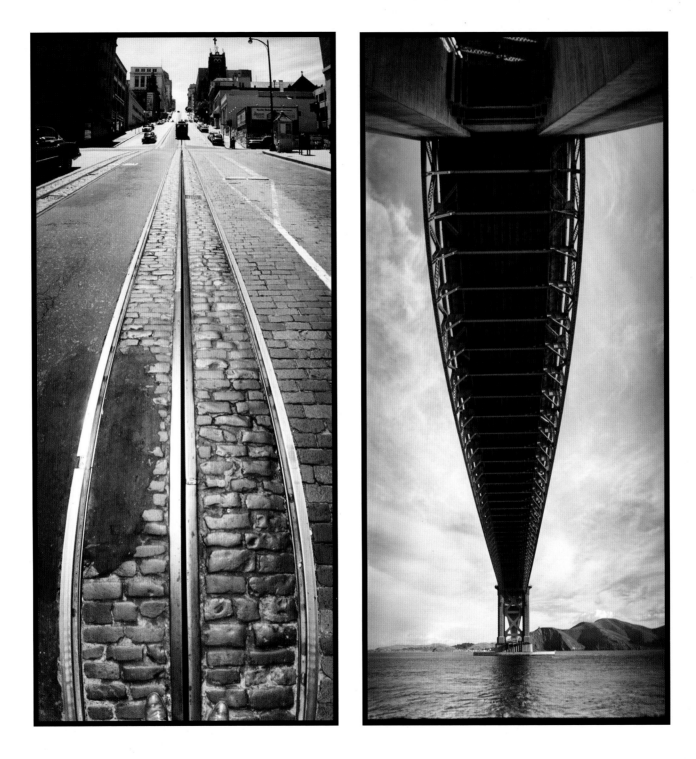

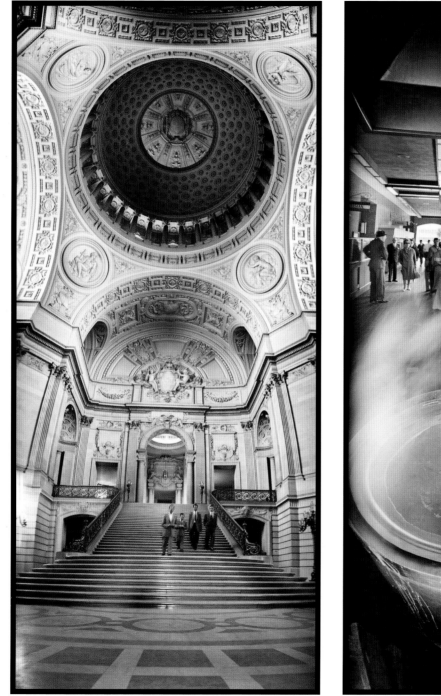
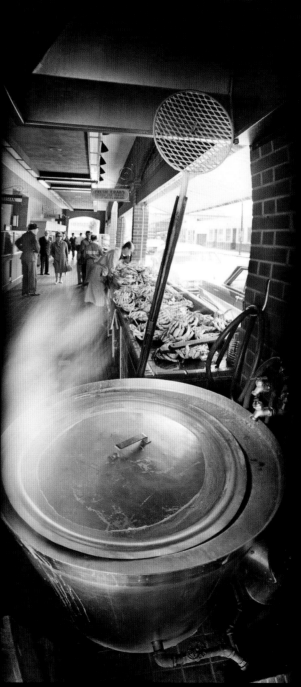

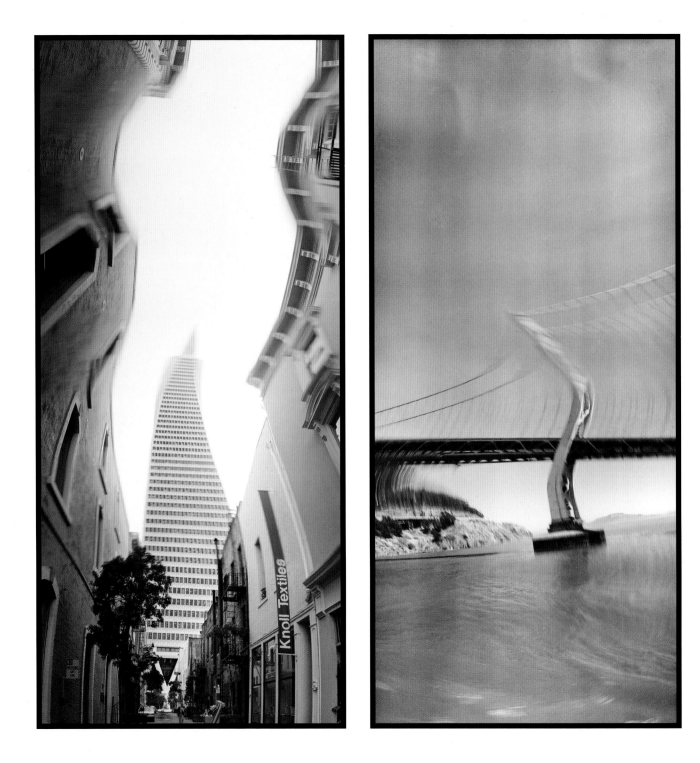

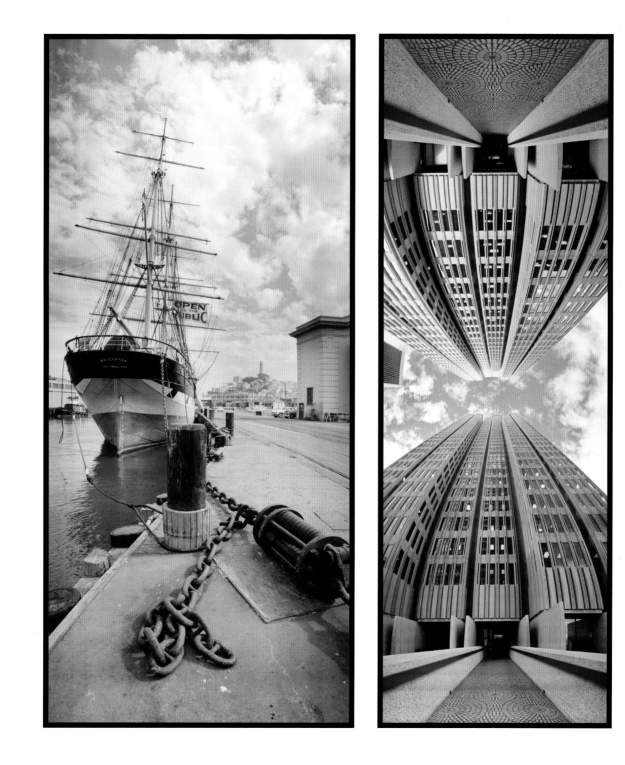

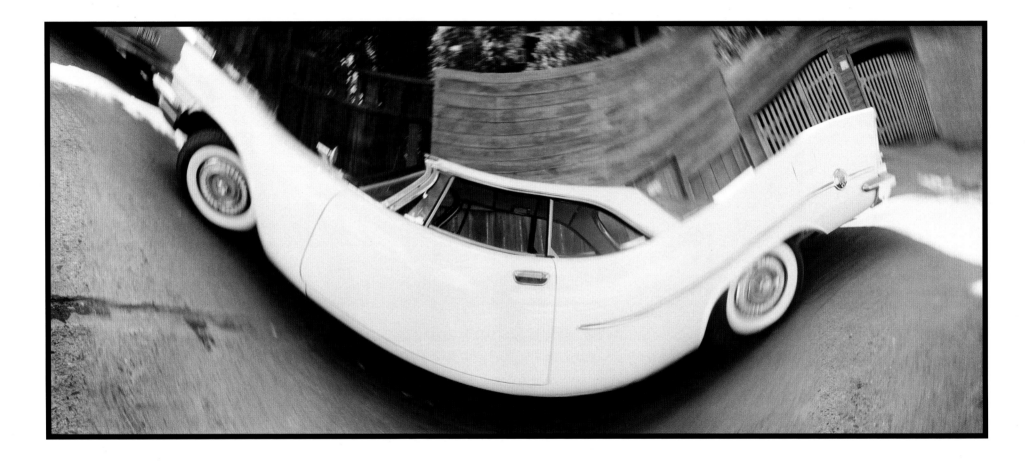

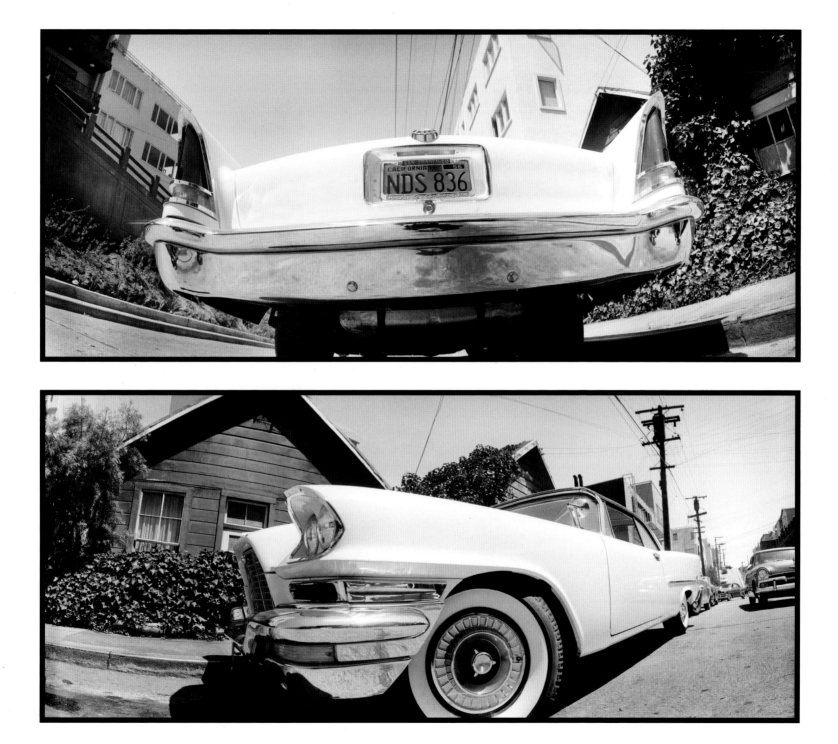

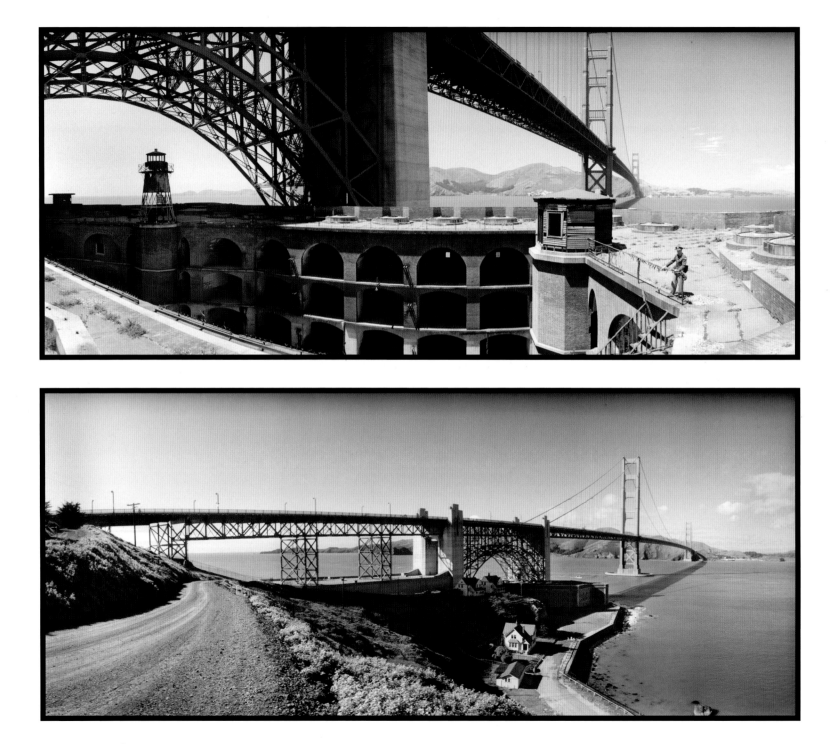

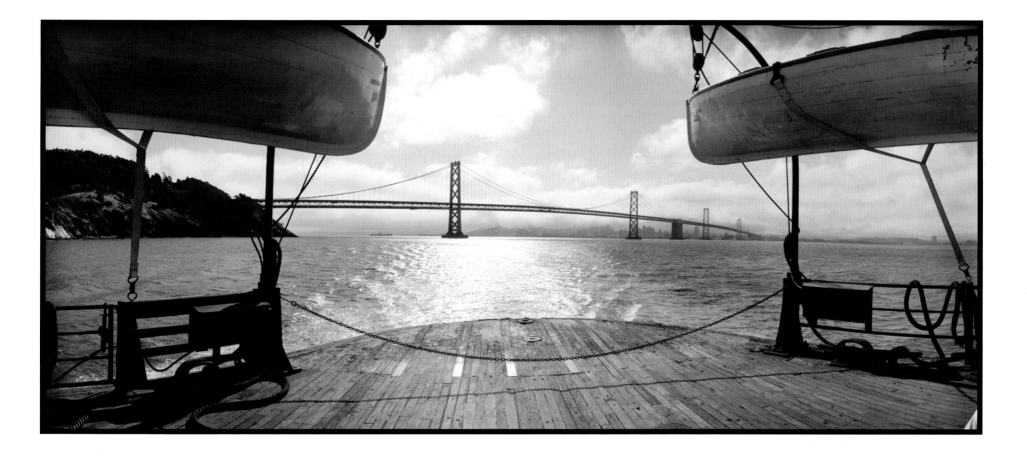

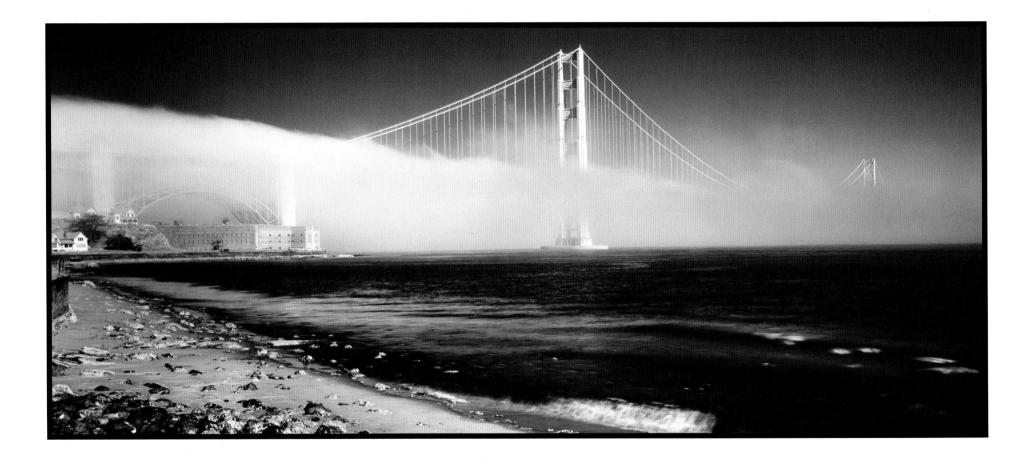

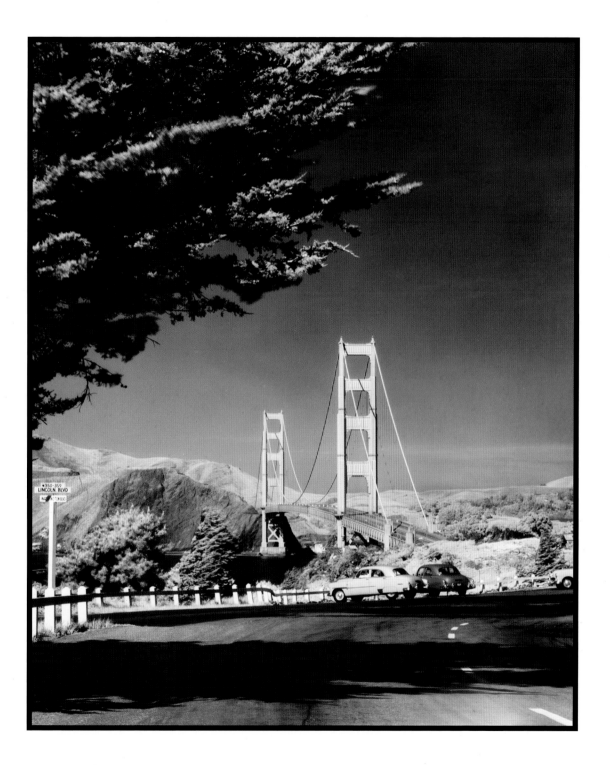

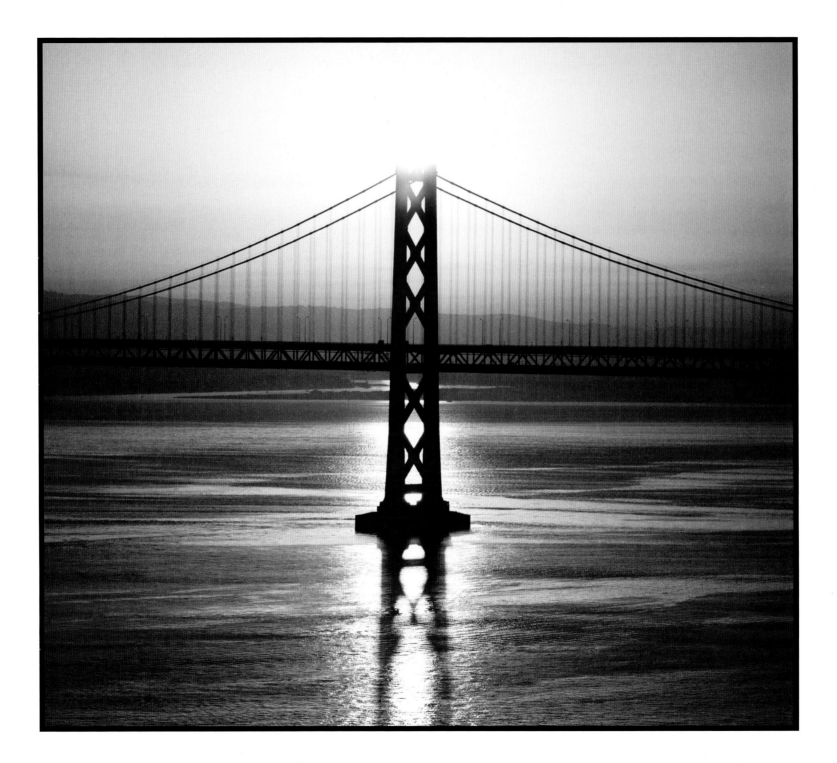

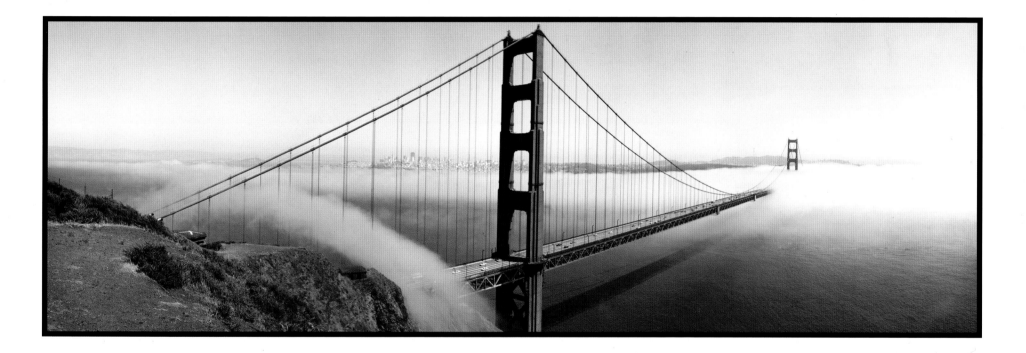

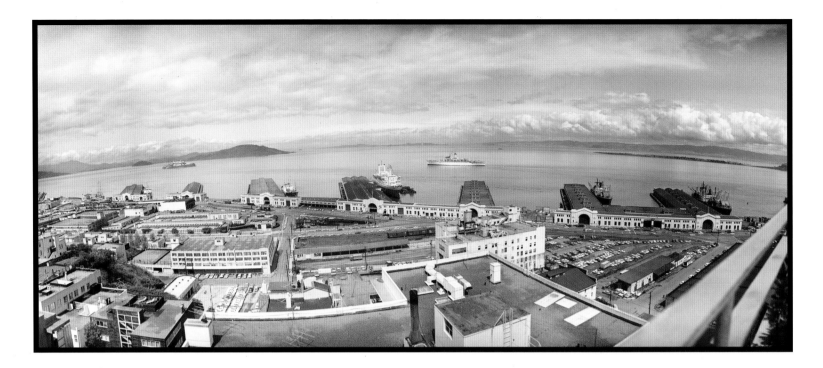

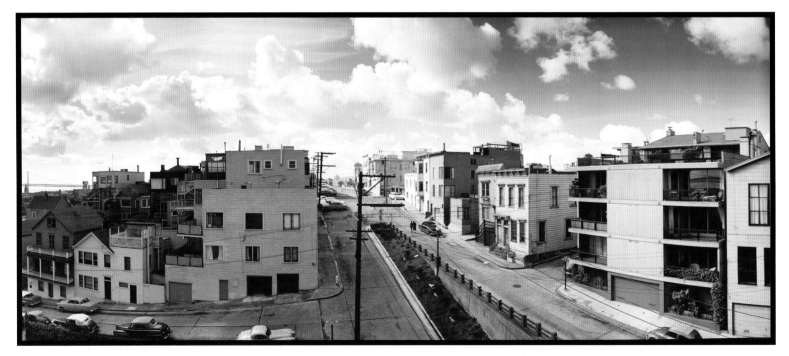

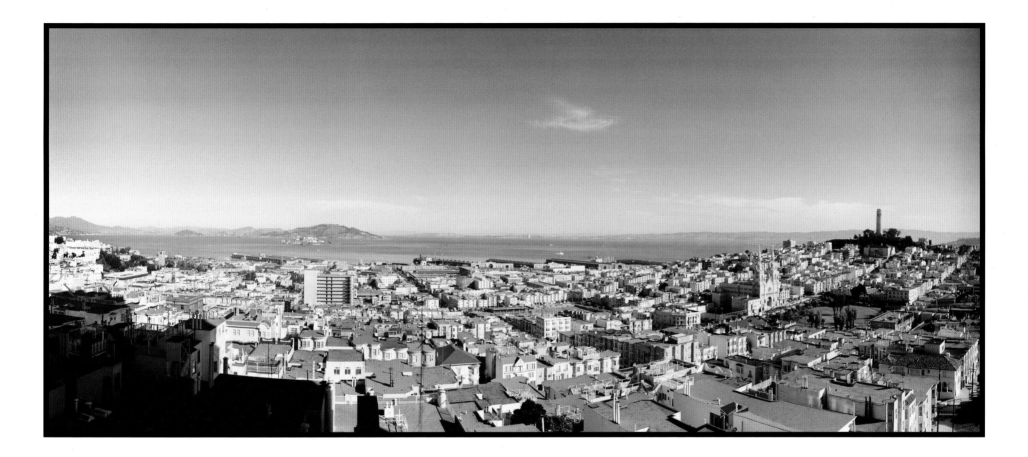

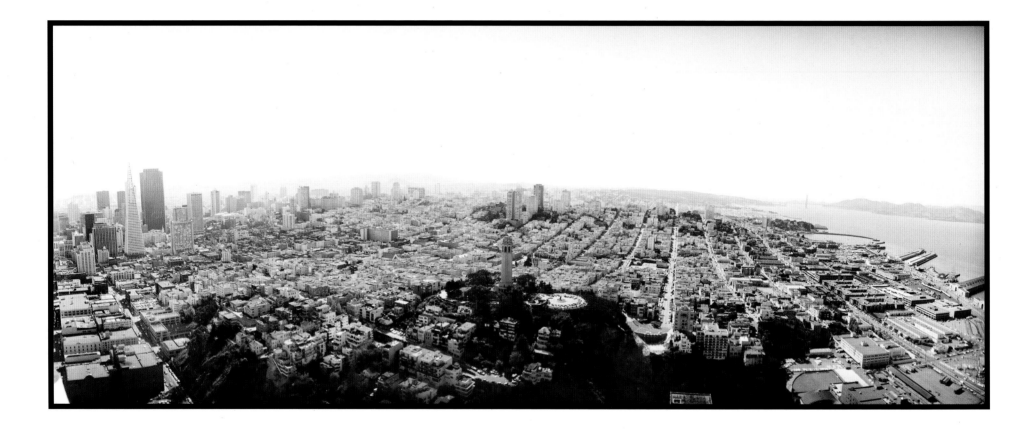

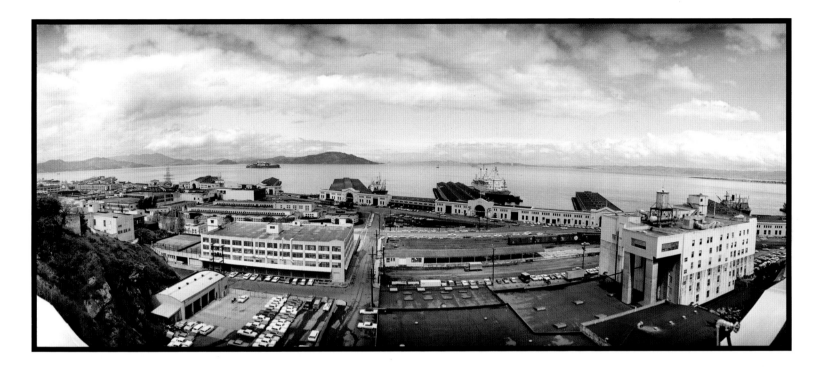

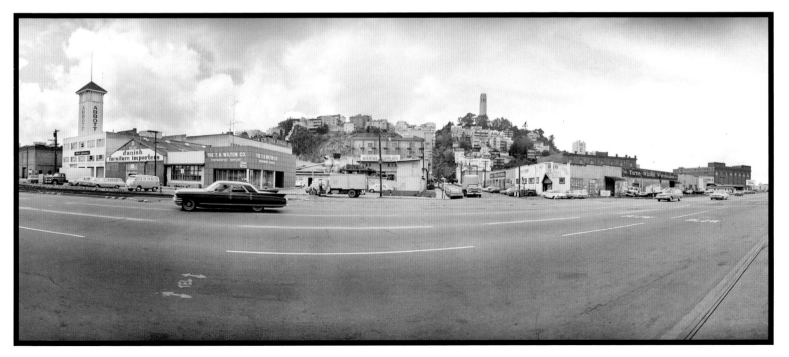

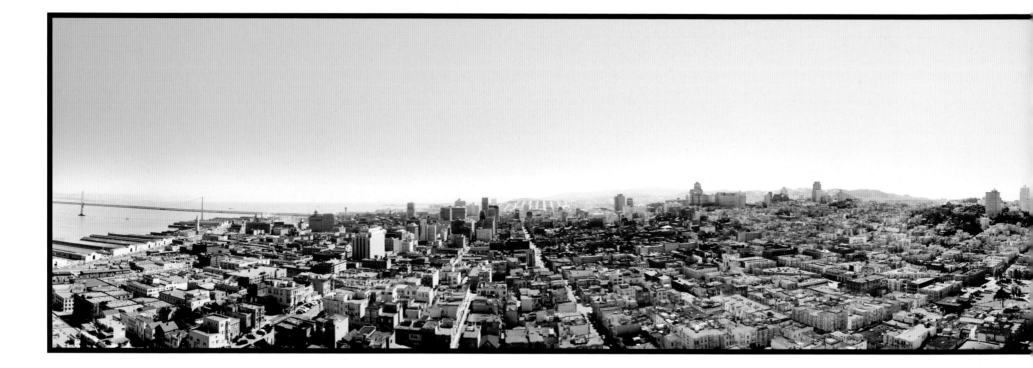

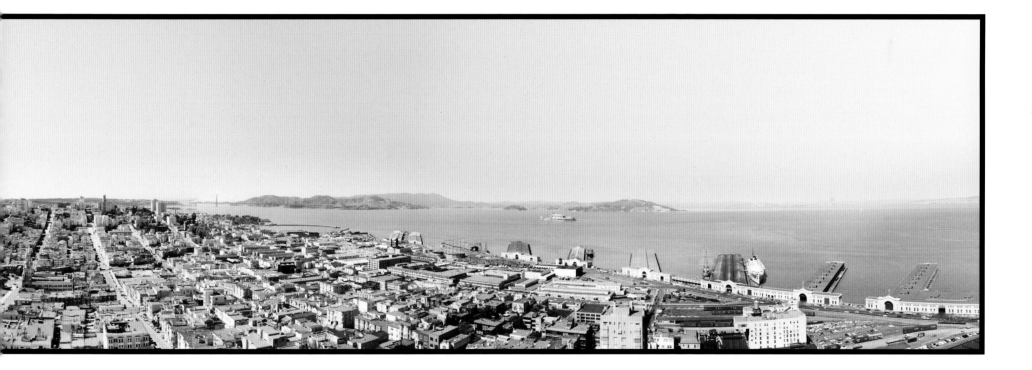

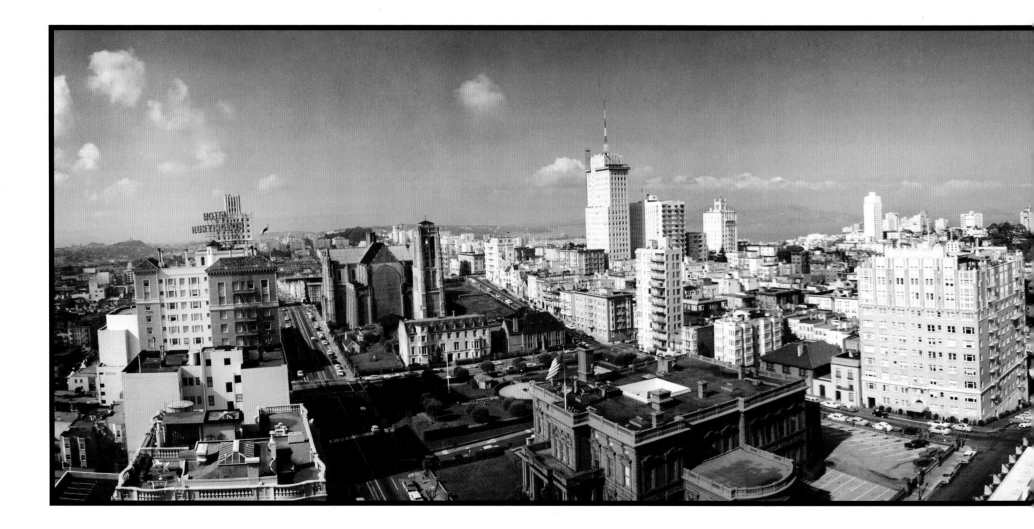

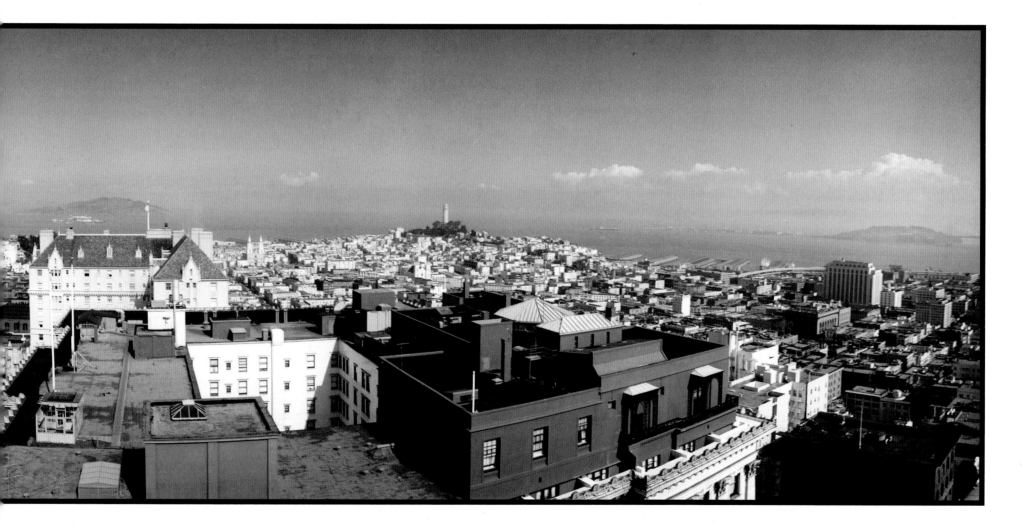

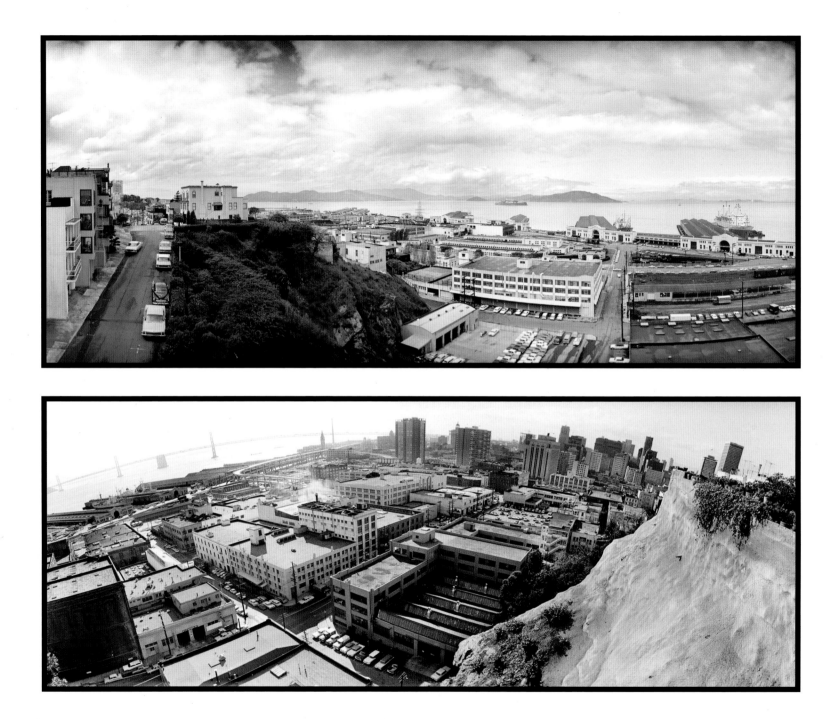

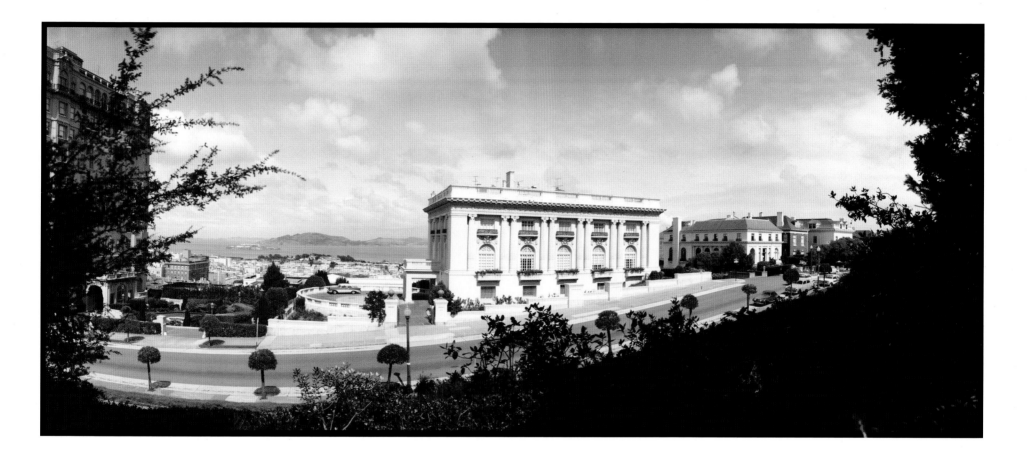

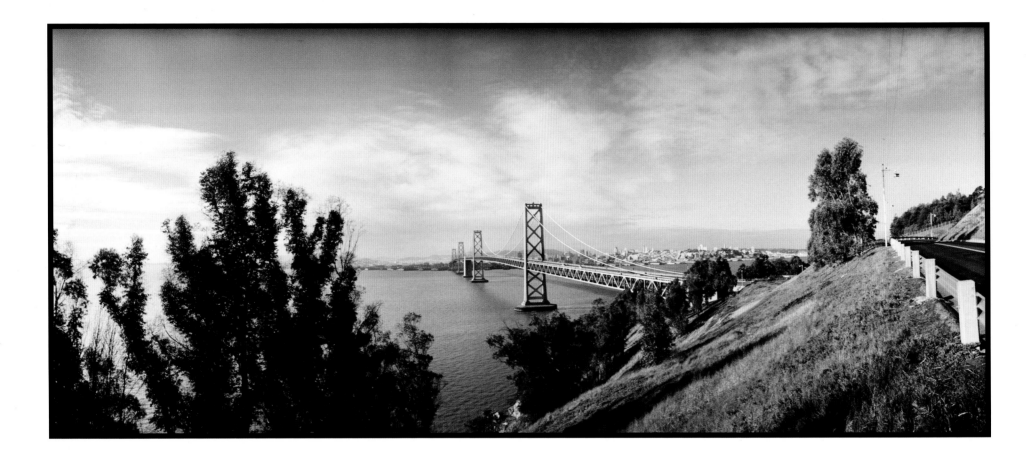

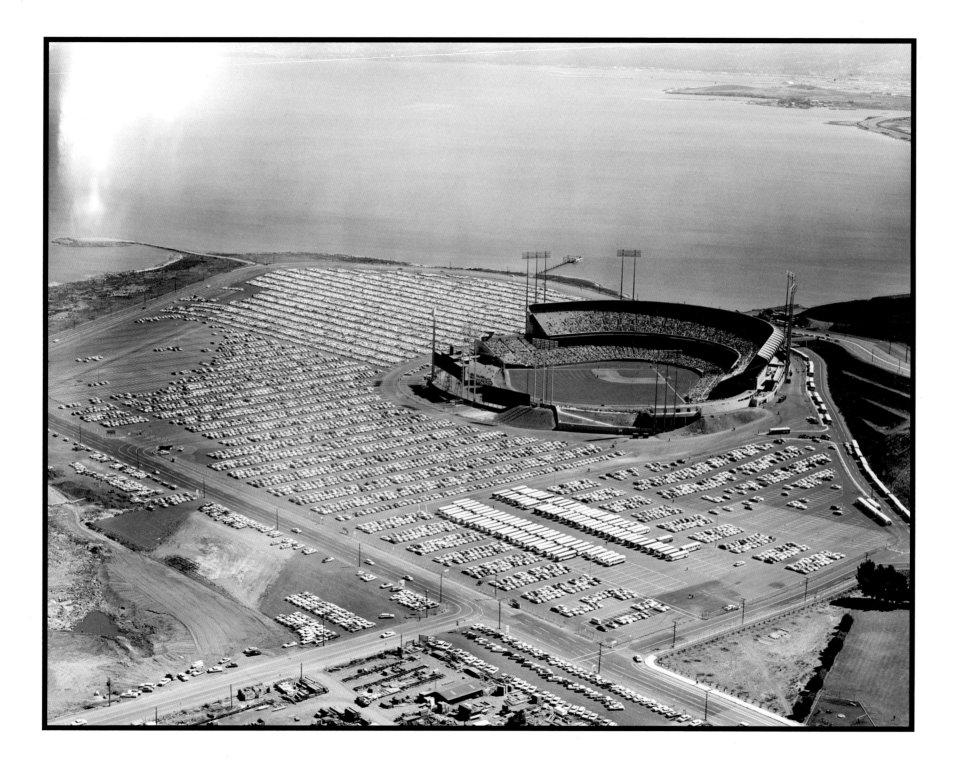

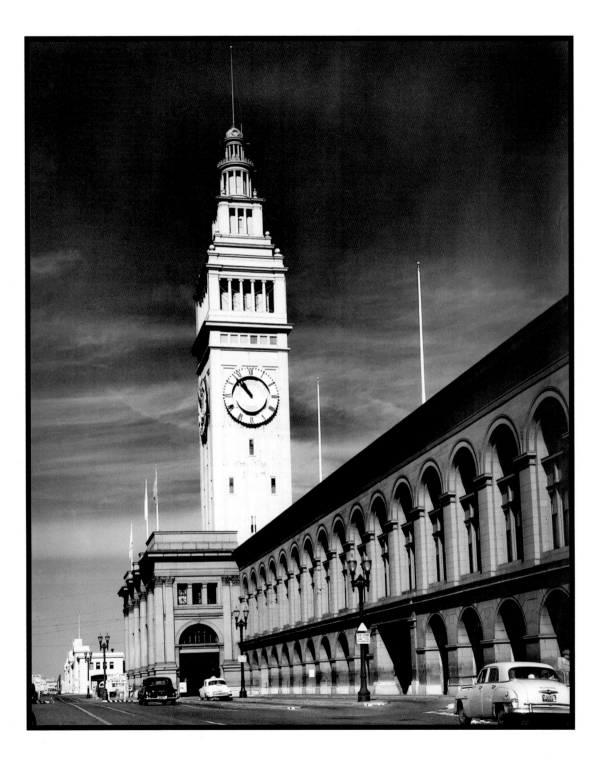

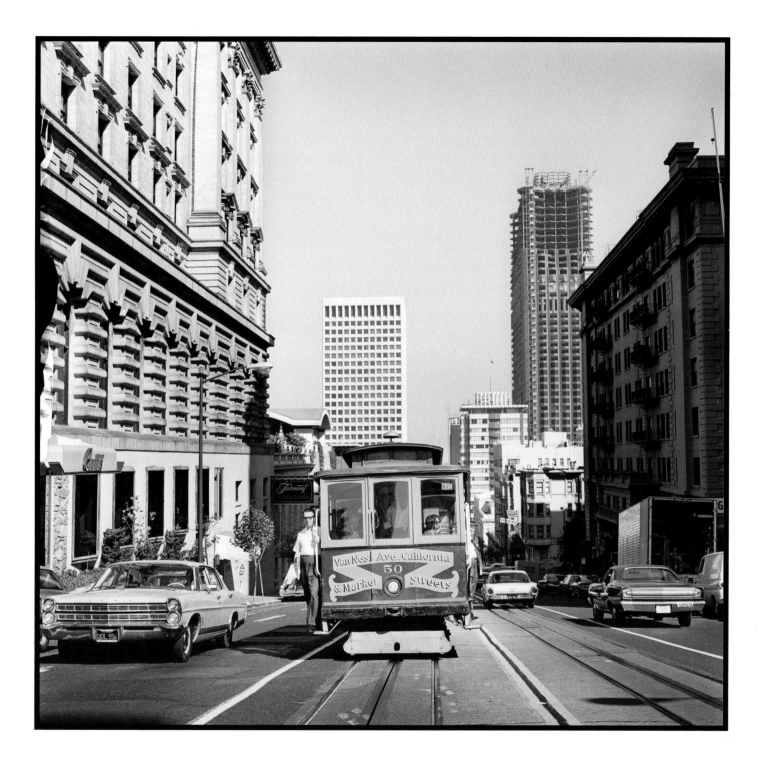

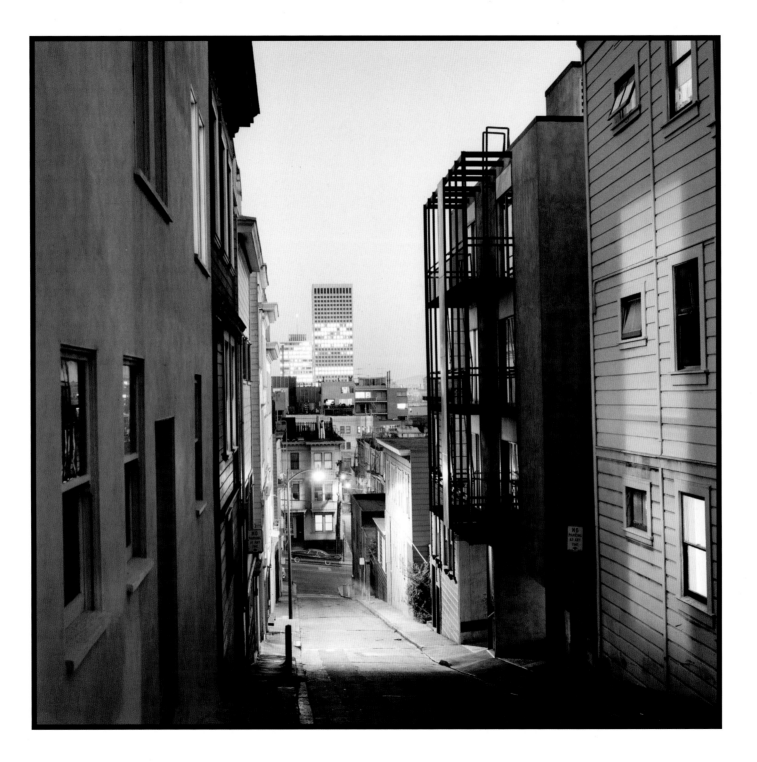

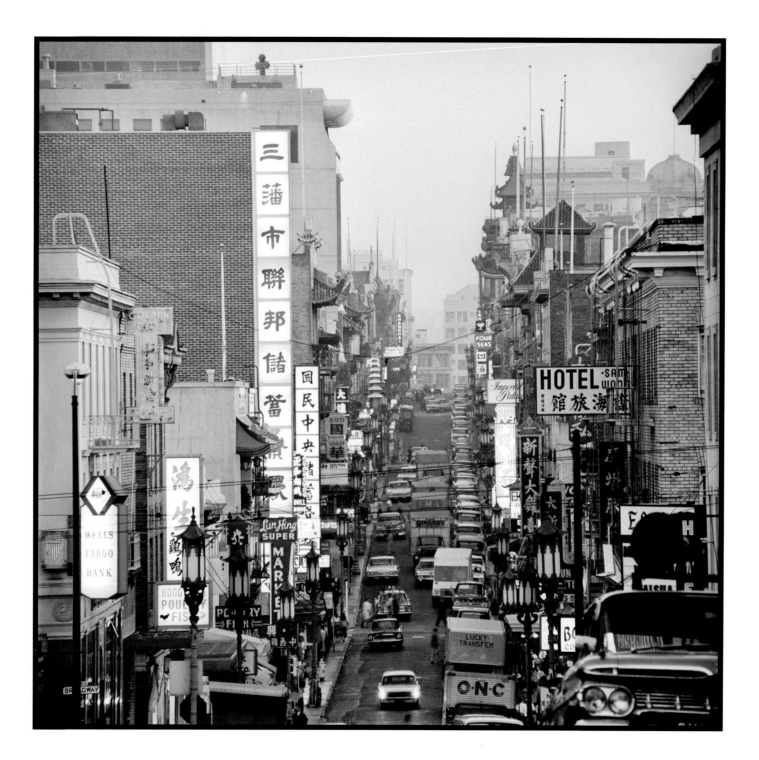

65

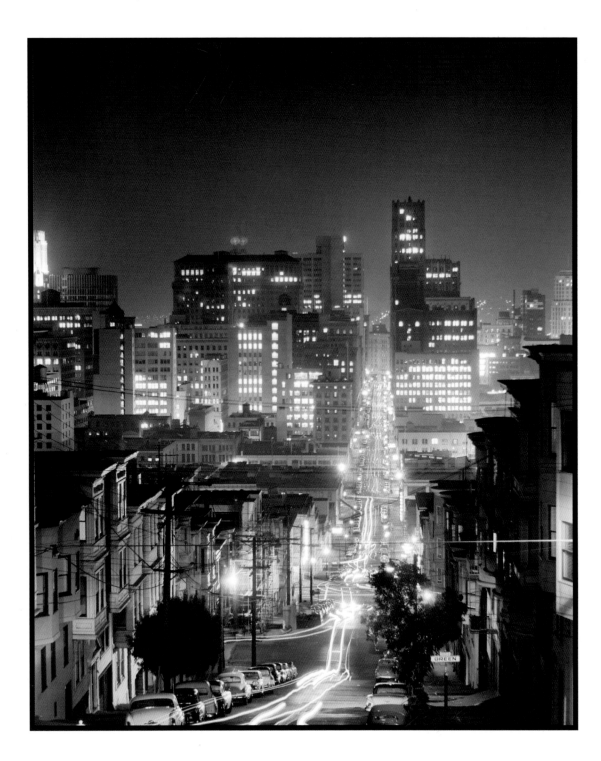

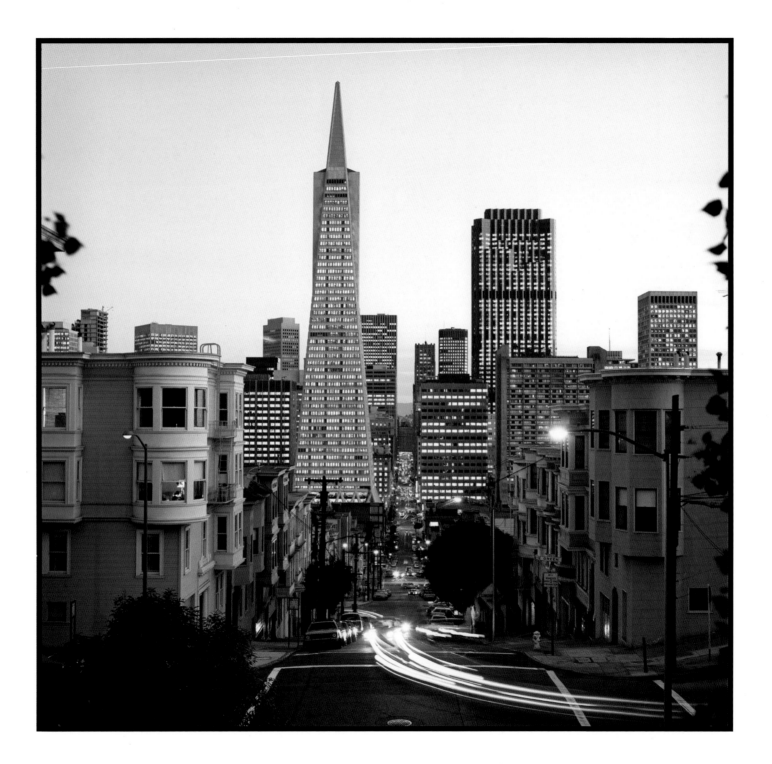

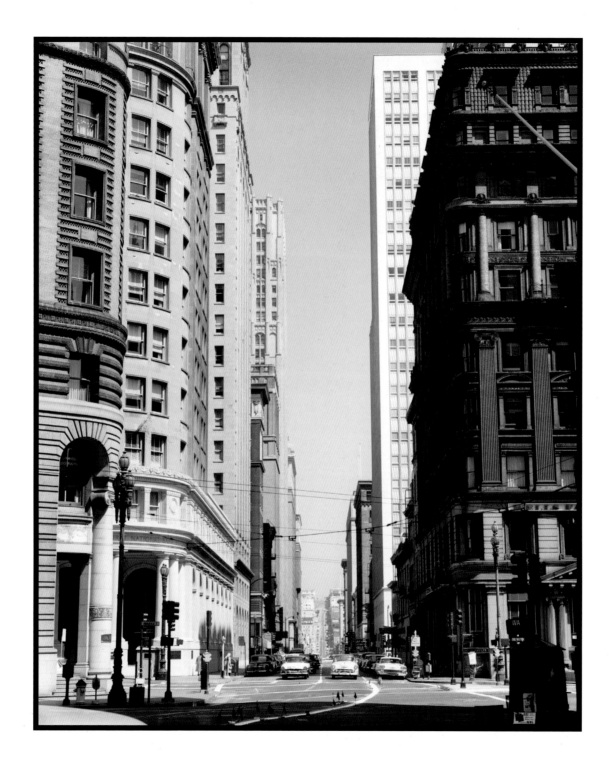

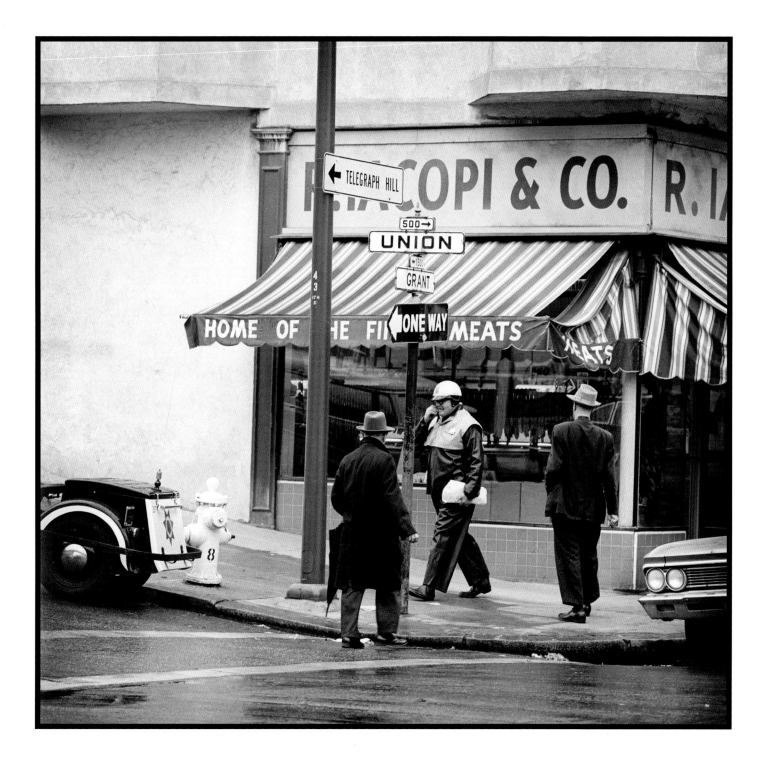

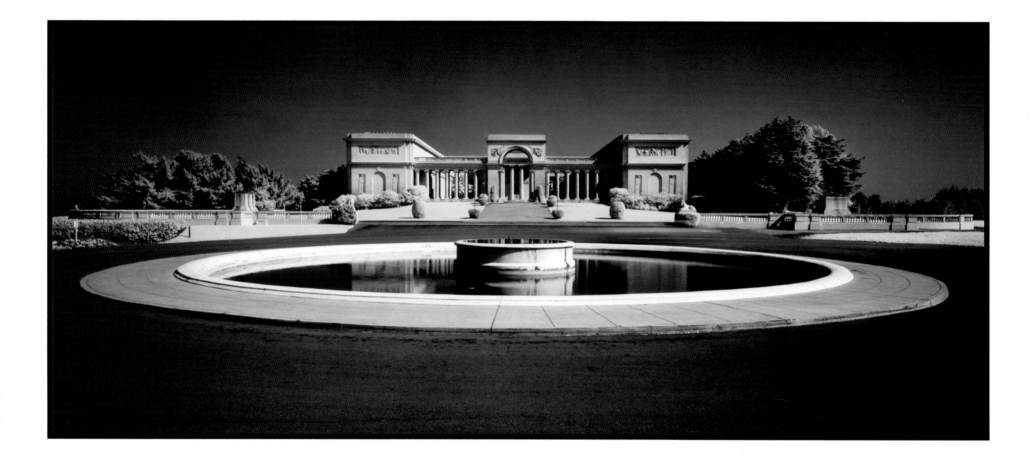

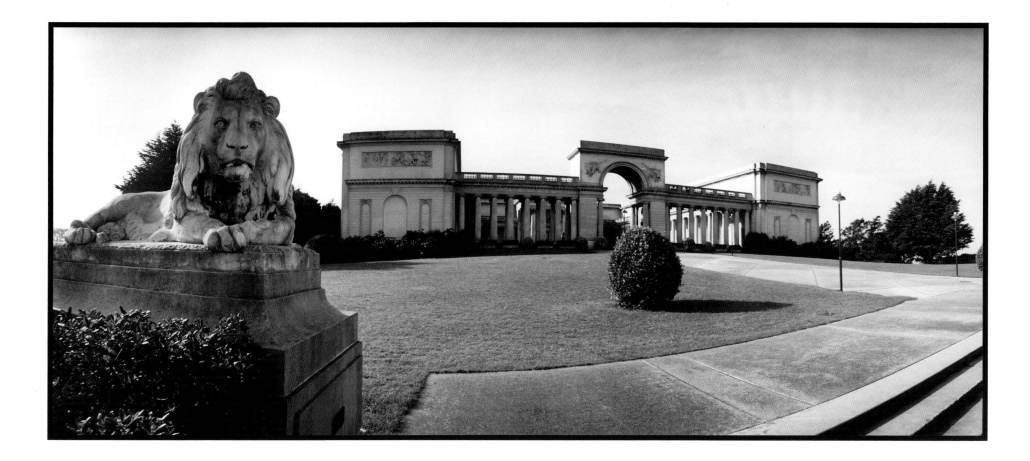

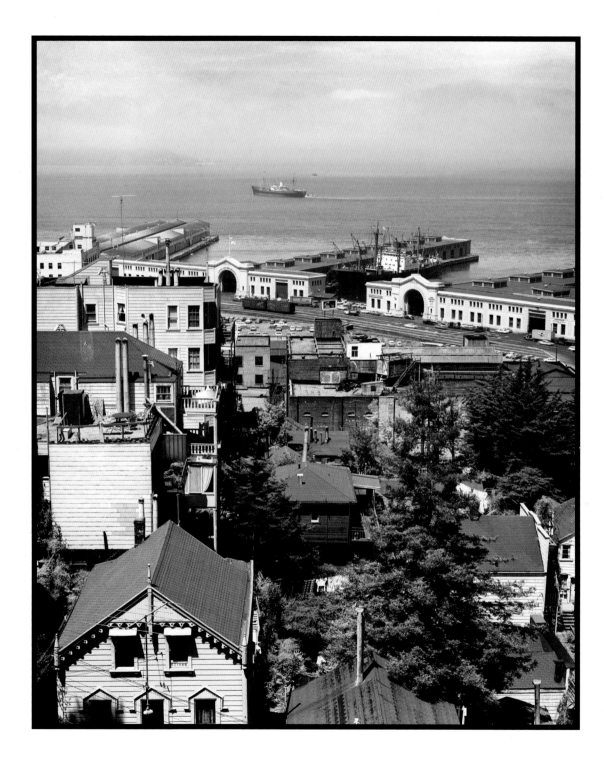

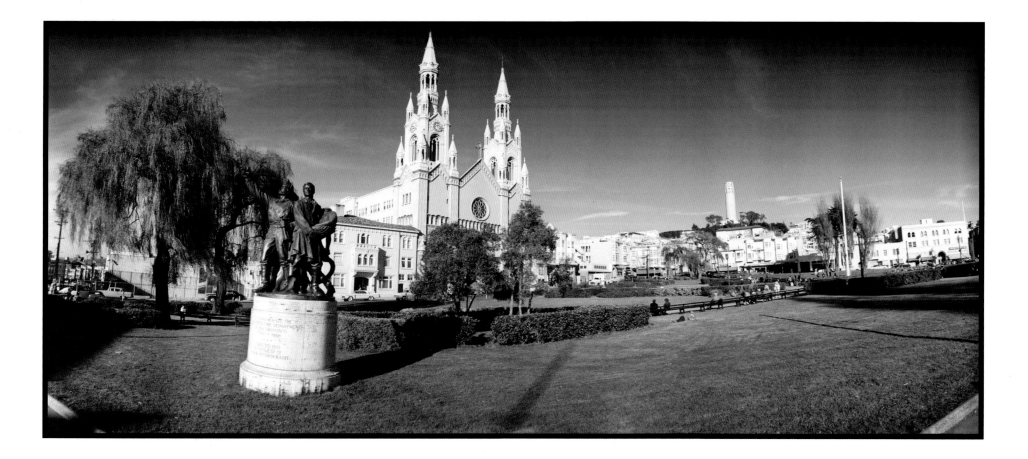

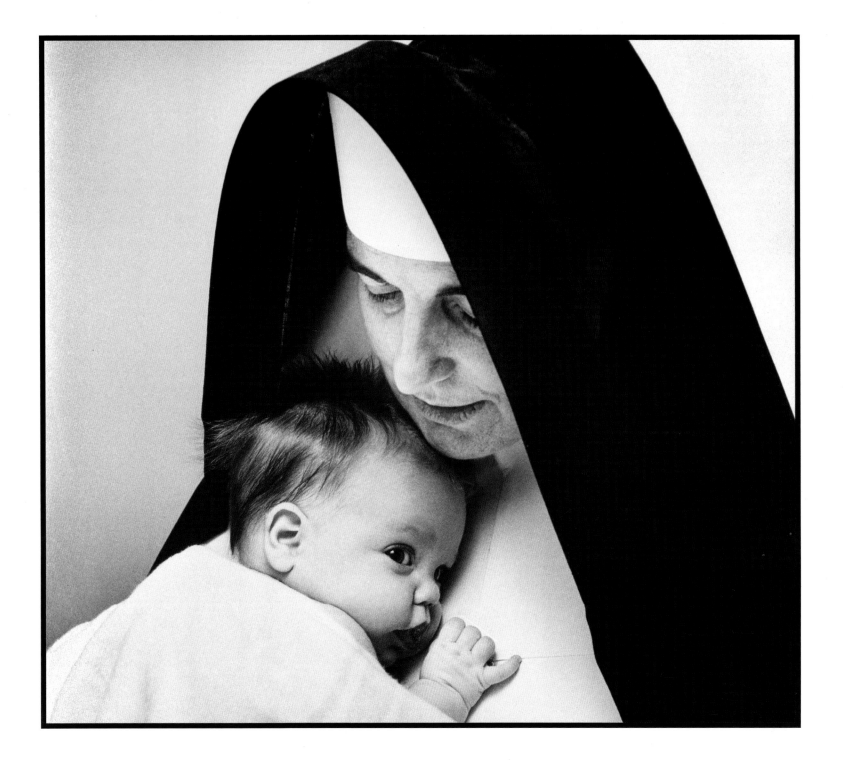

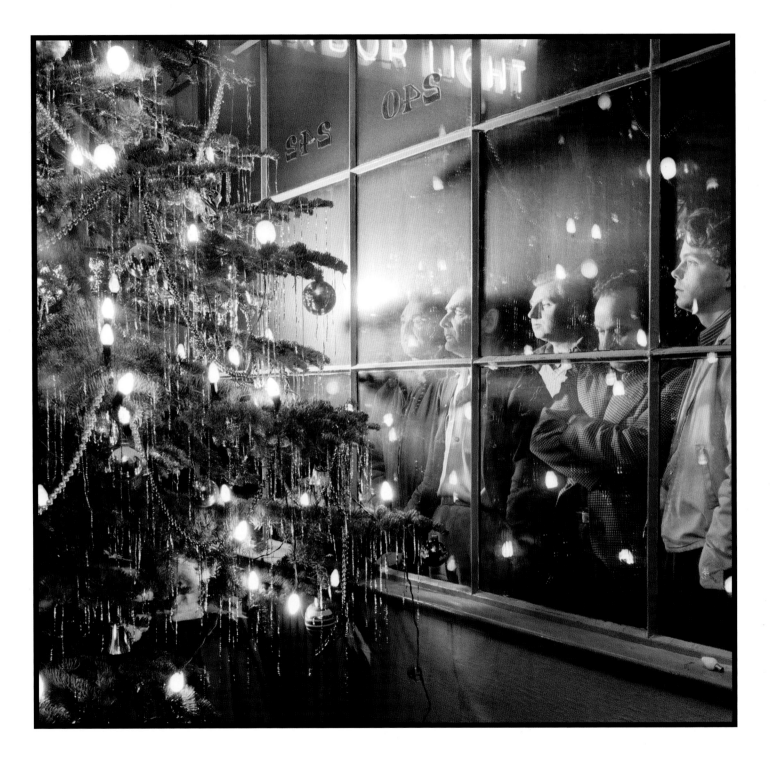

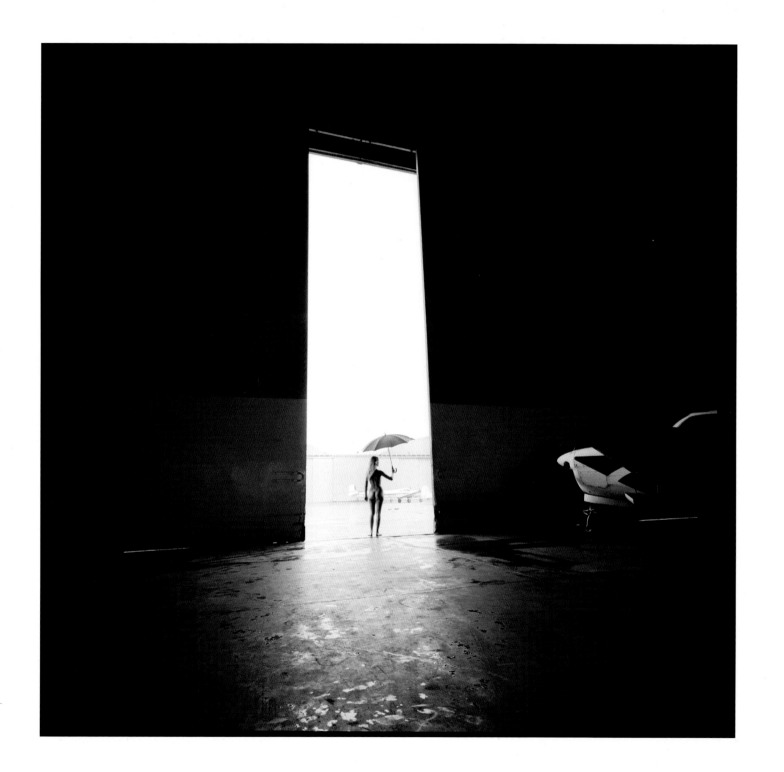

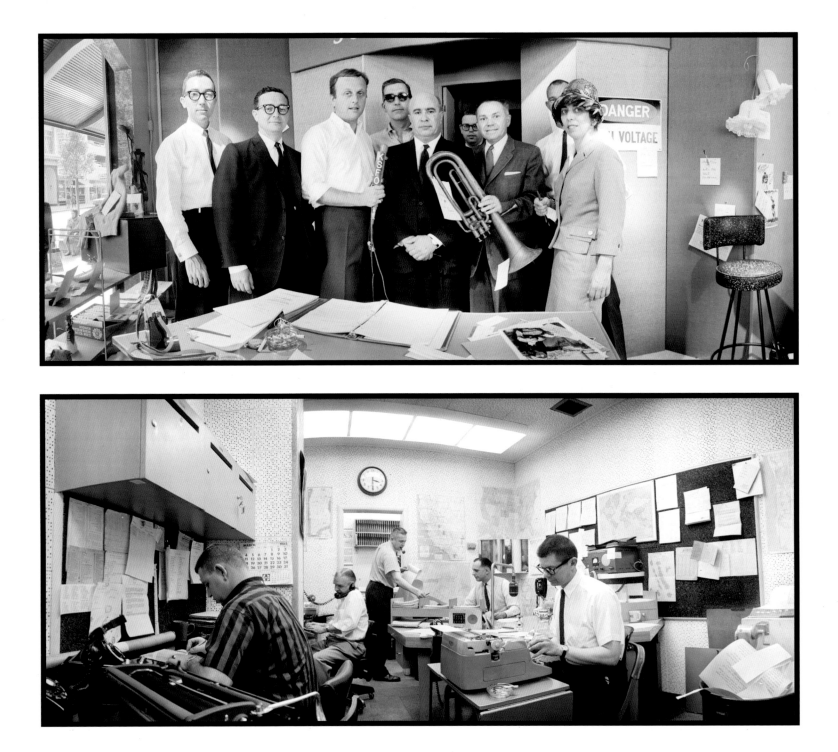

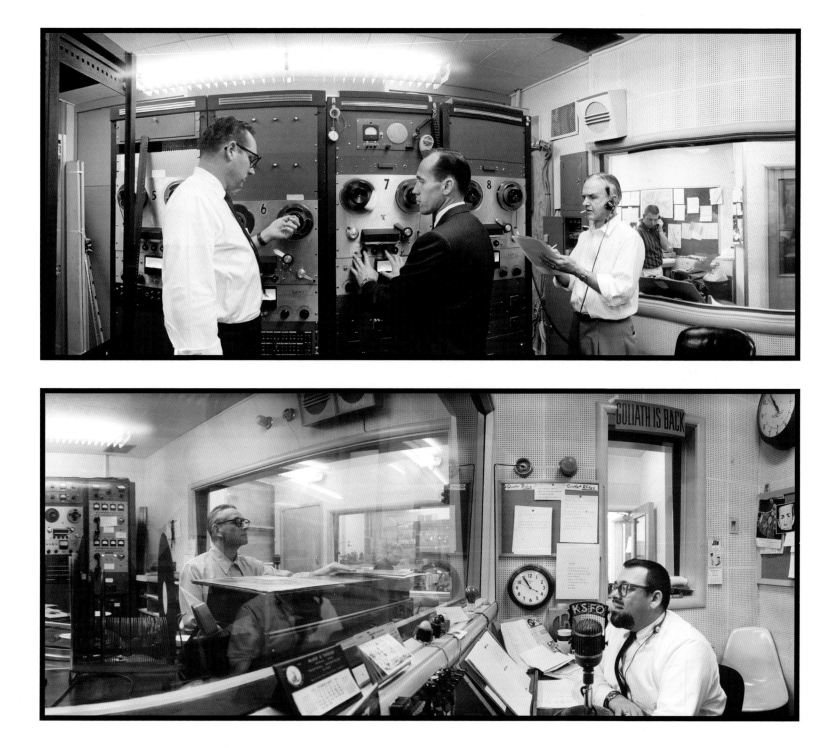

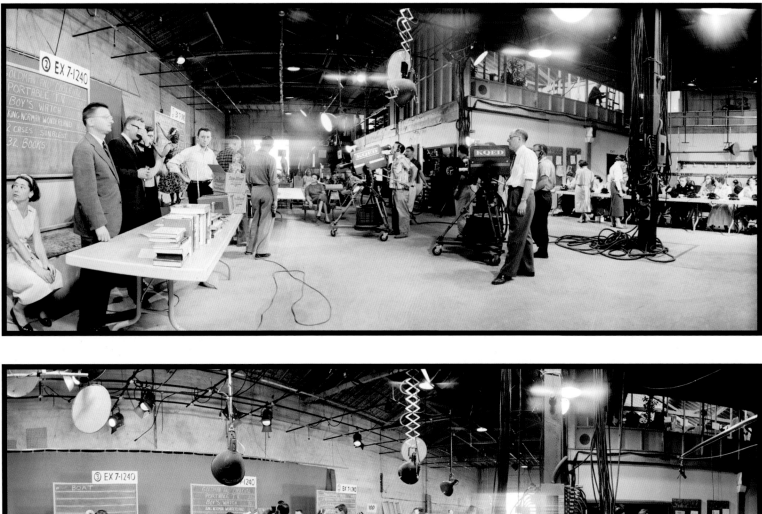

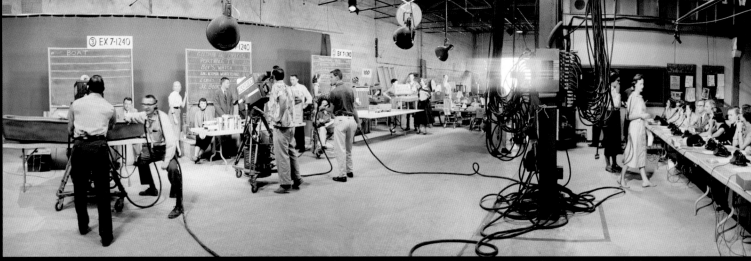

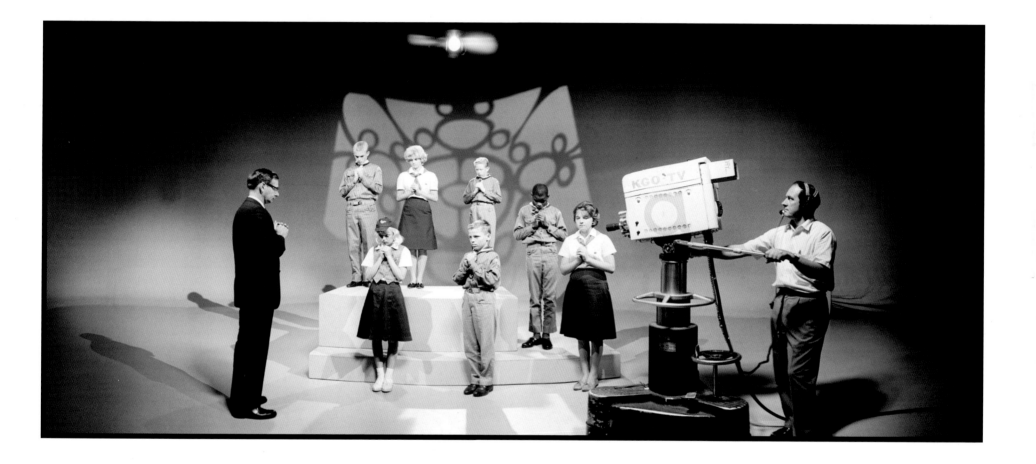

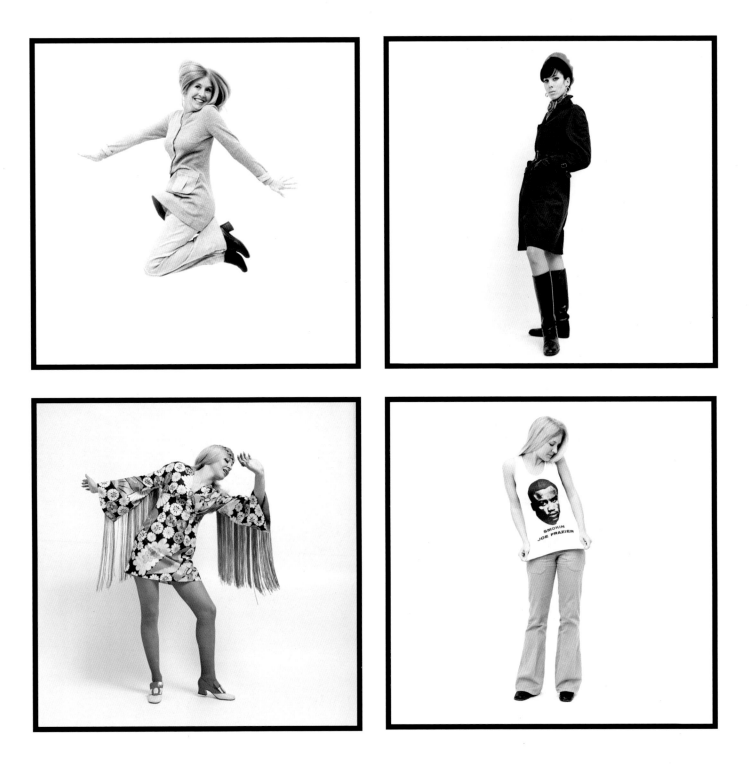

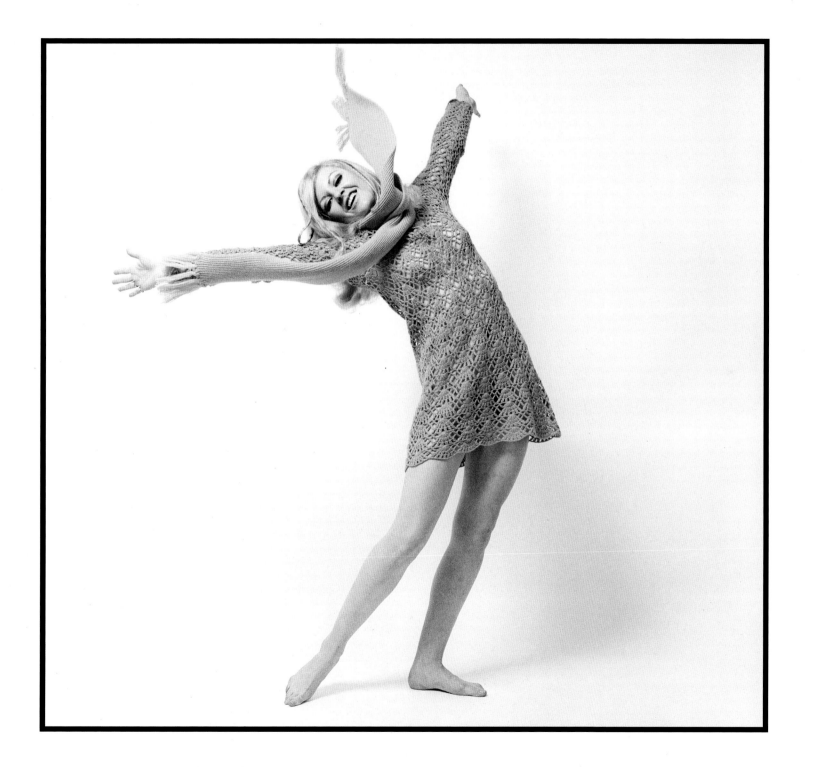

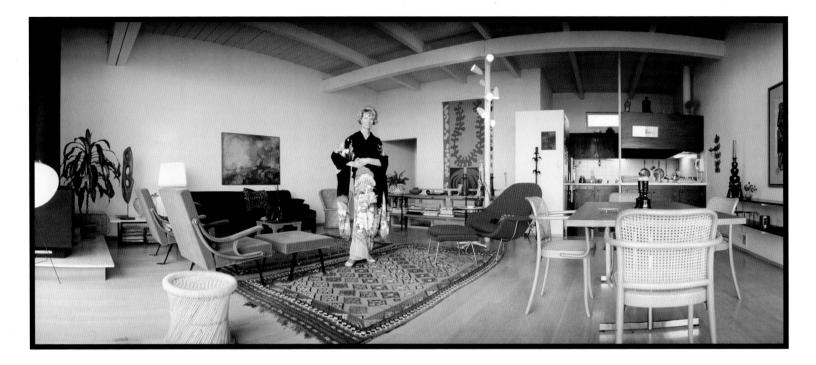

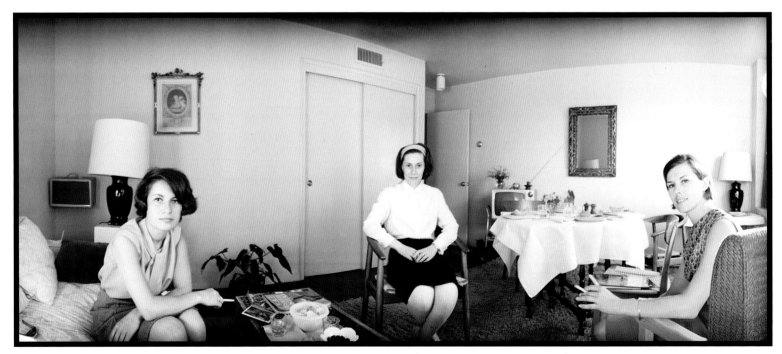

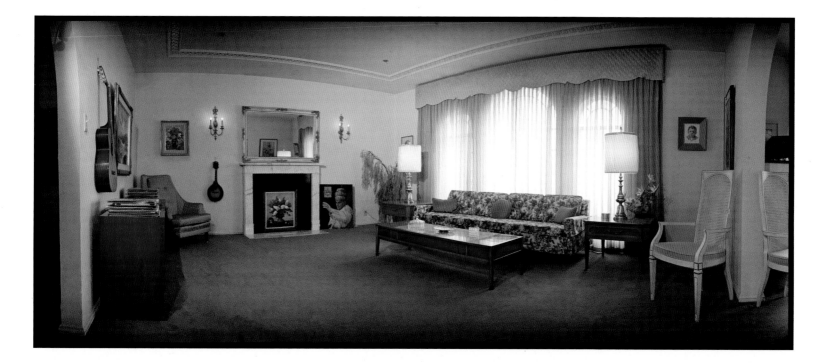

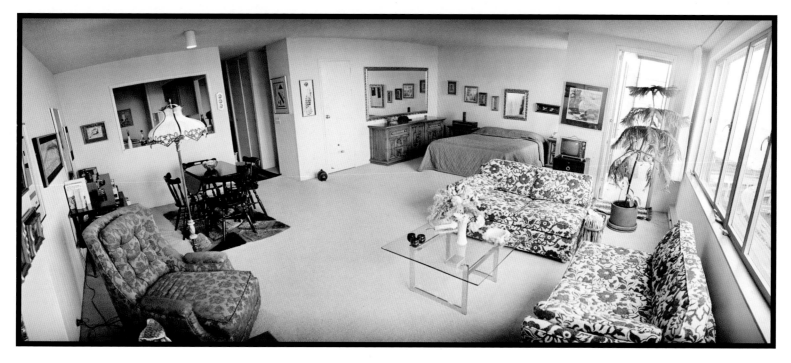

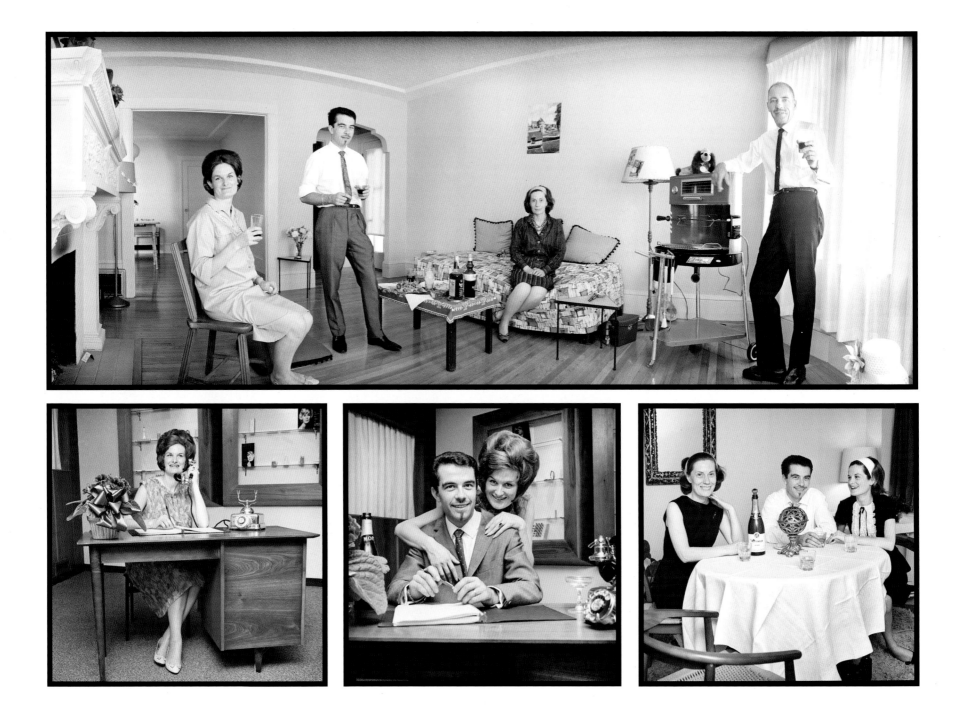

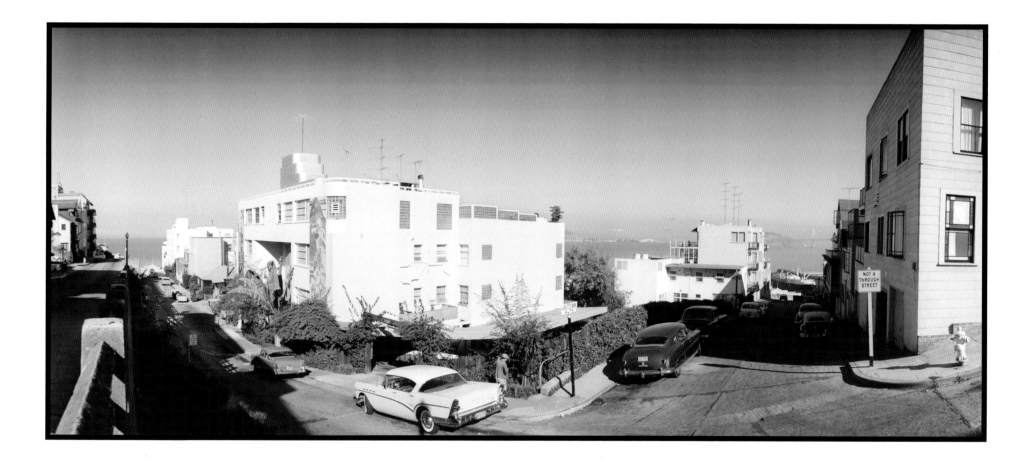

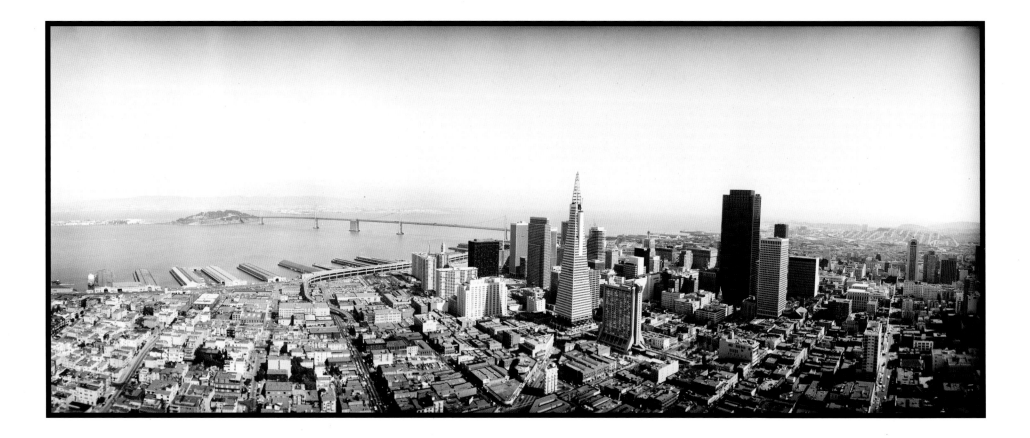

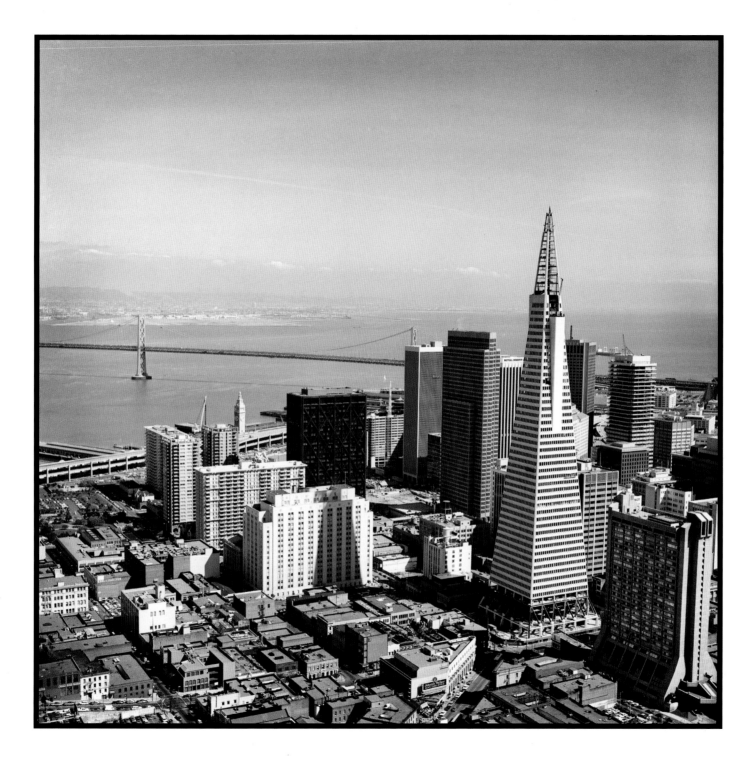

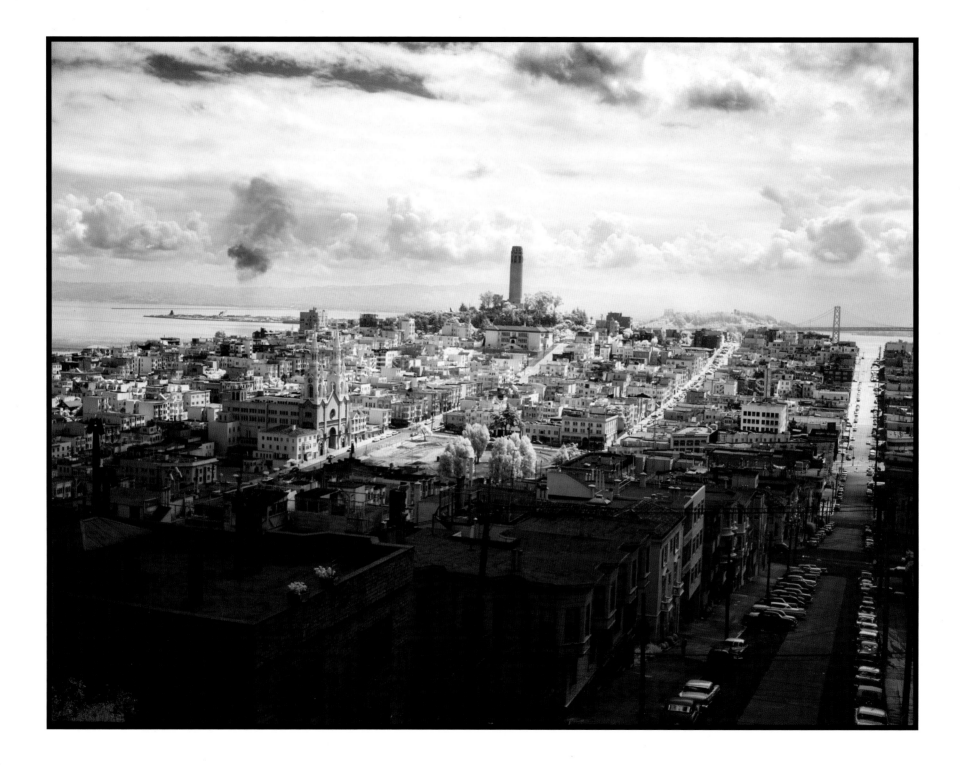

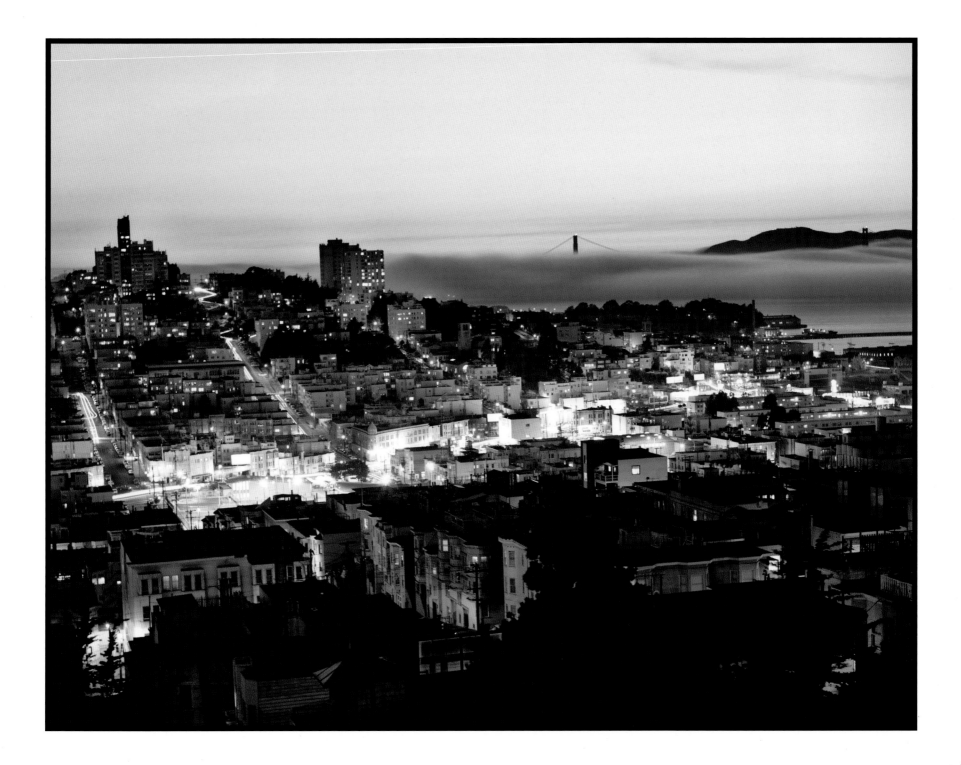

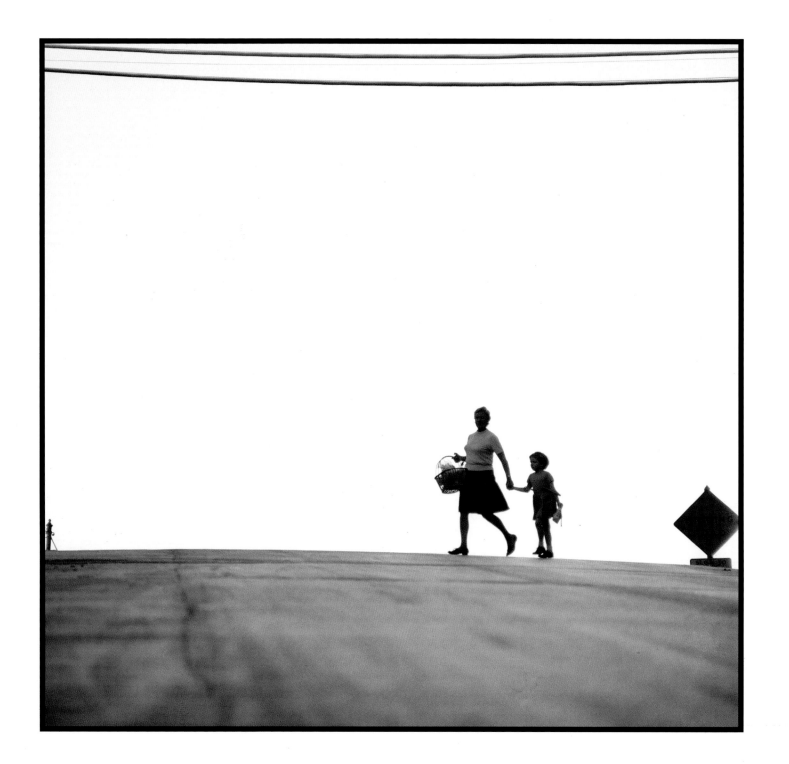

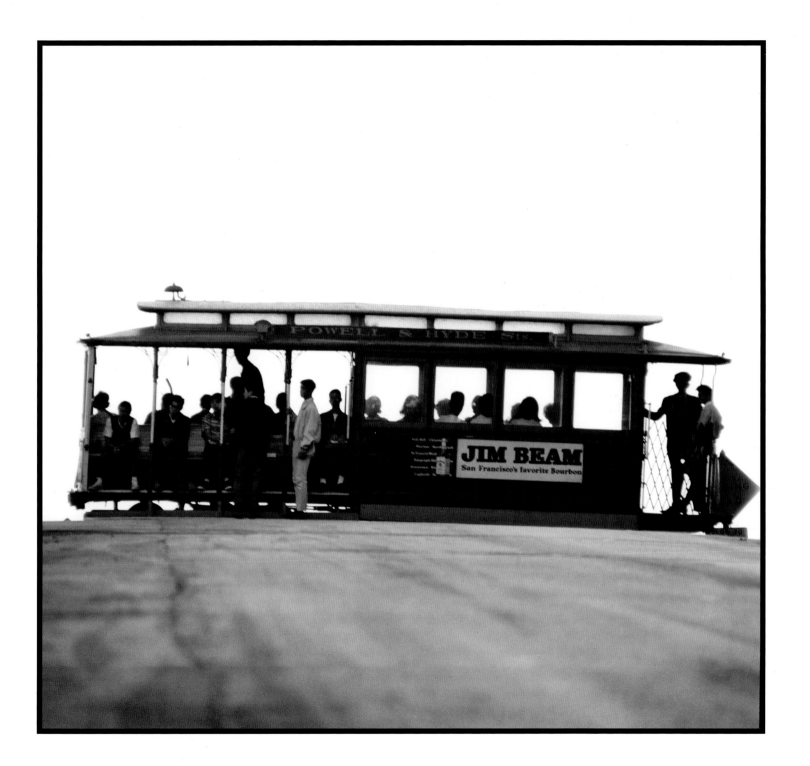

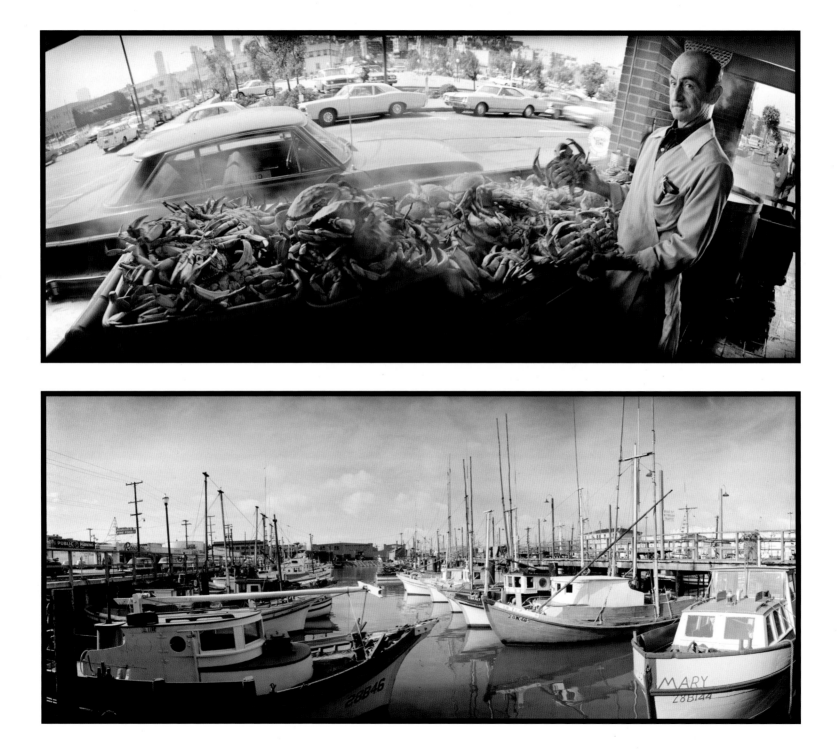

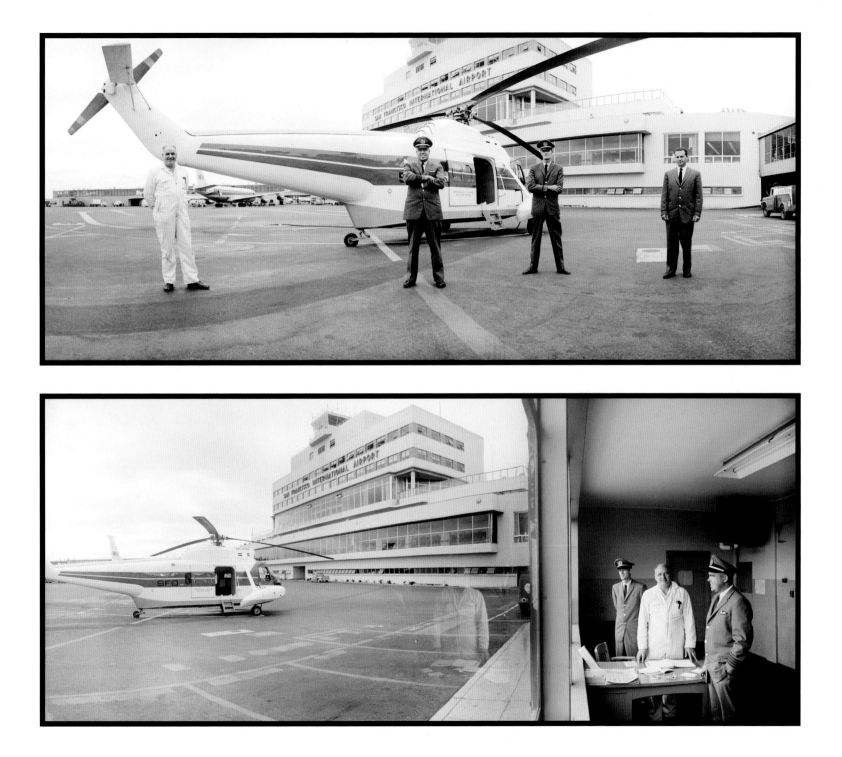

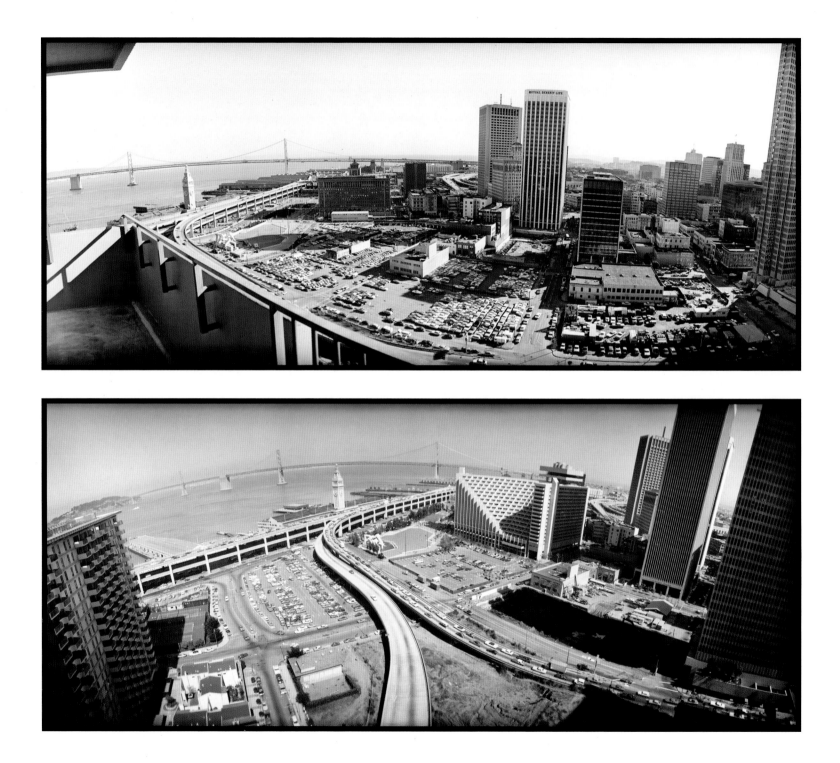

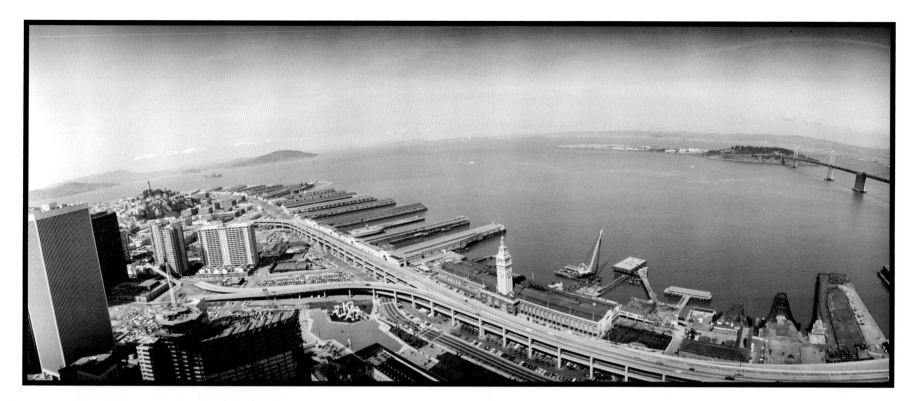

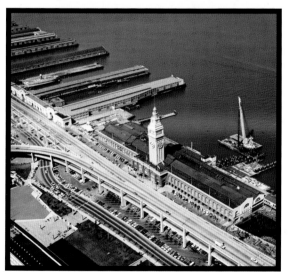
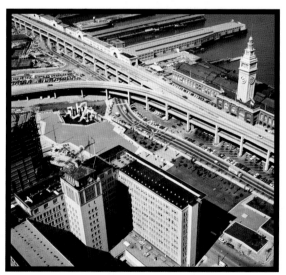
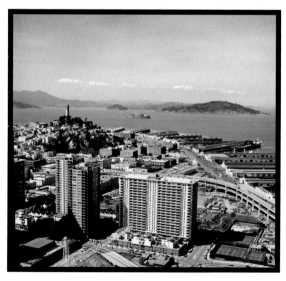

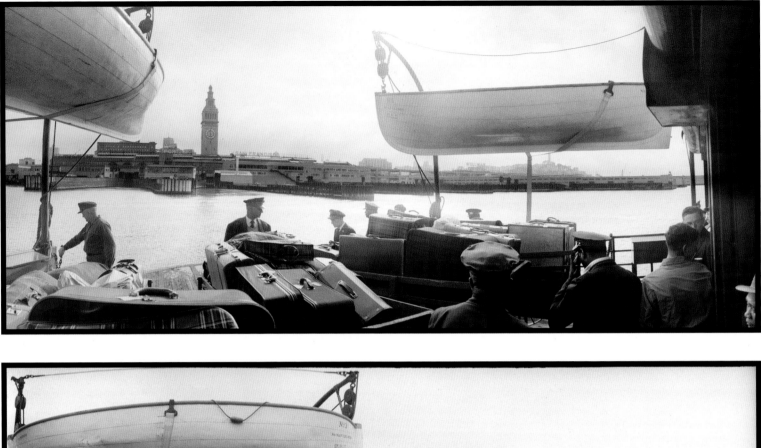

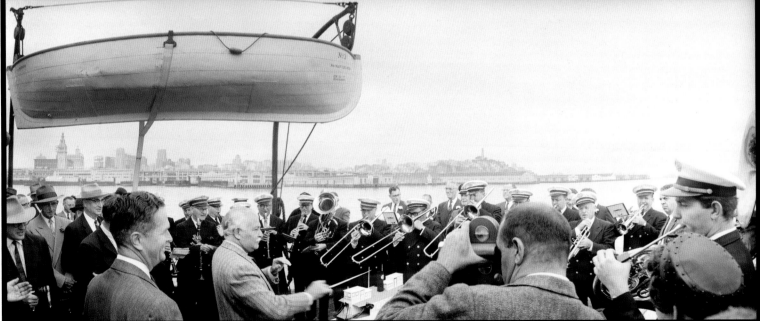

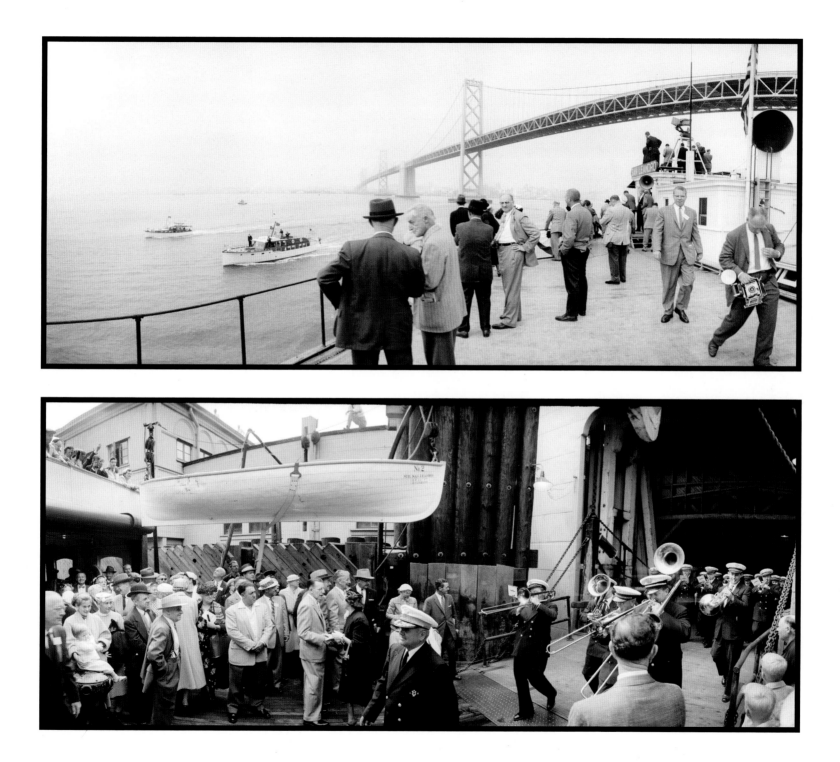

100

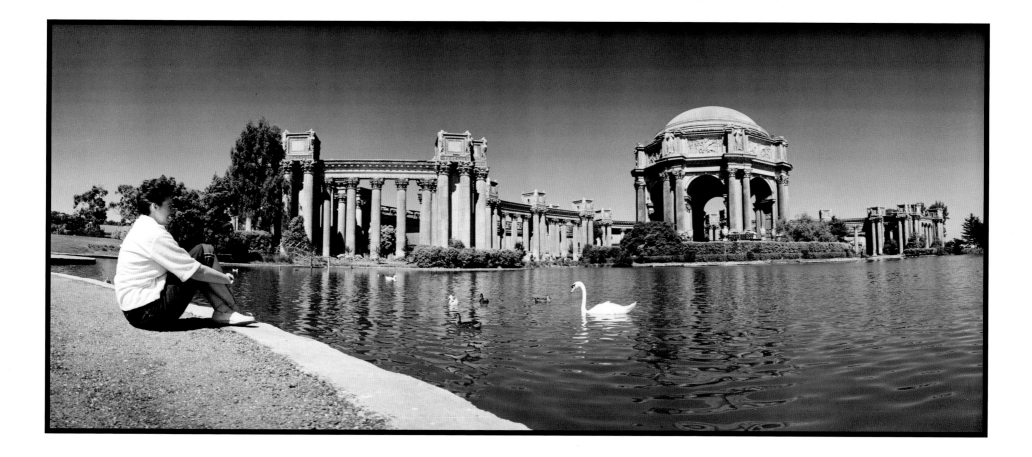

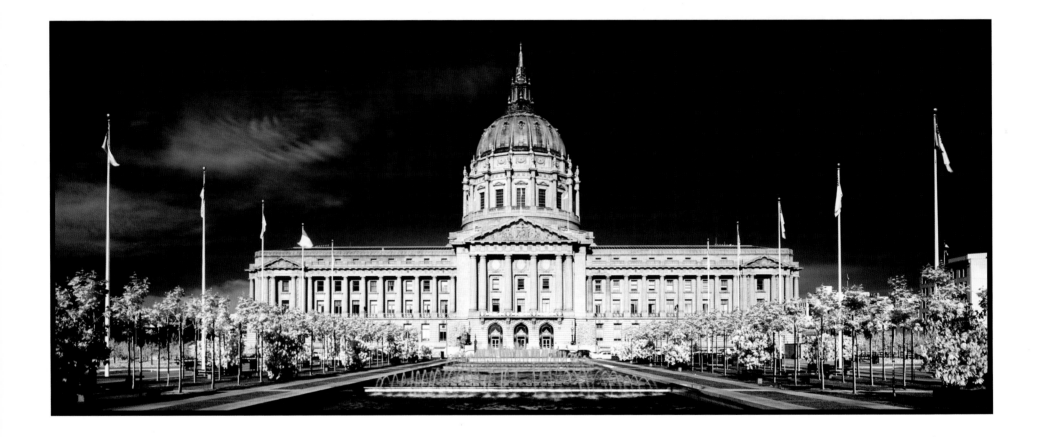

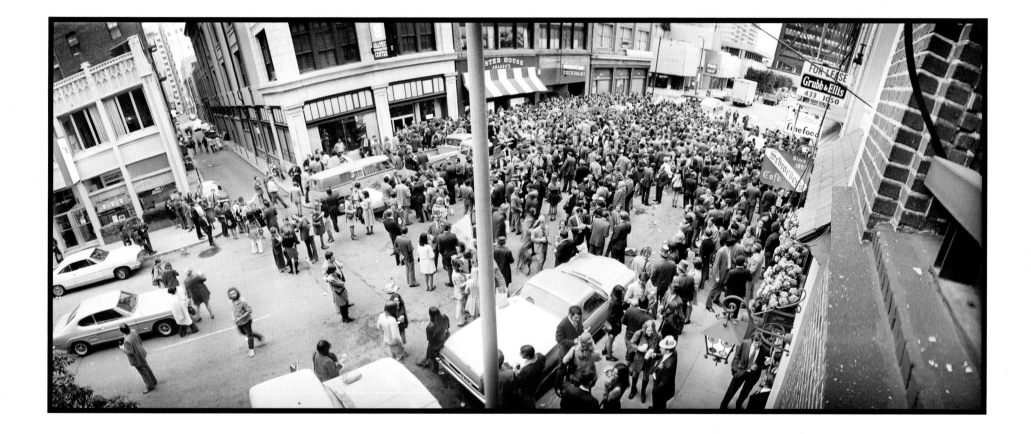

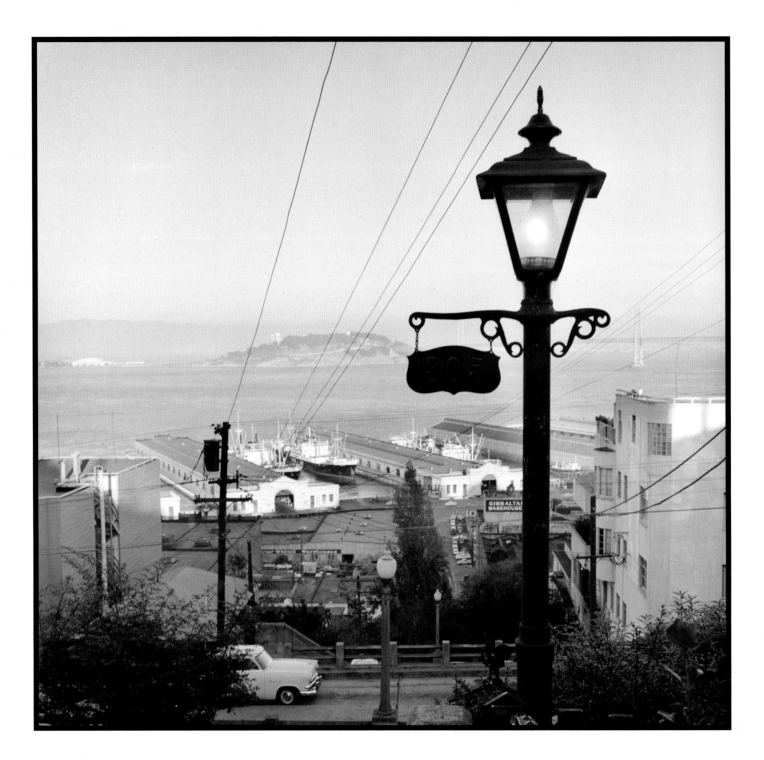

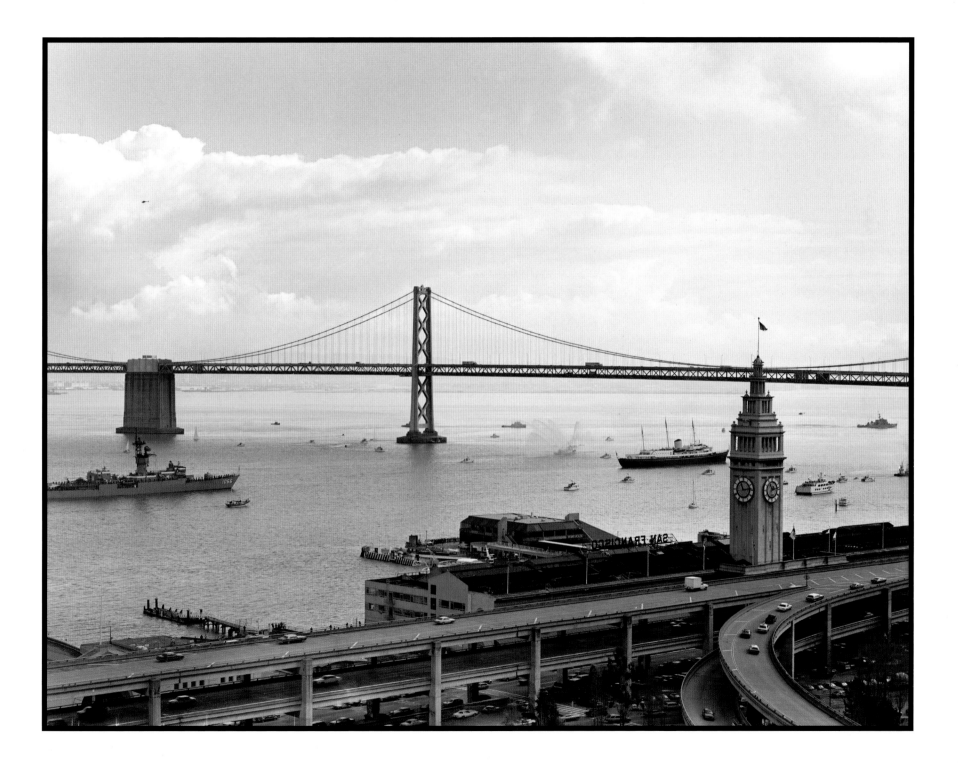

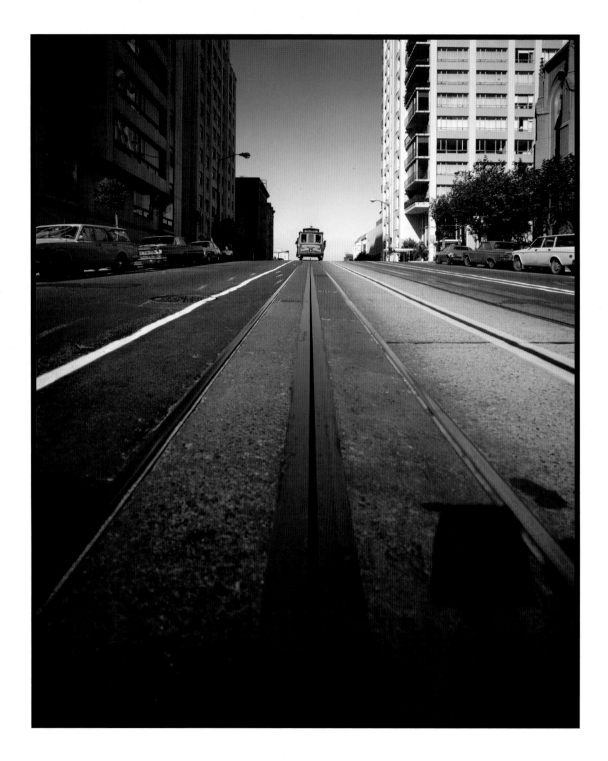

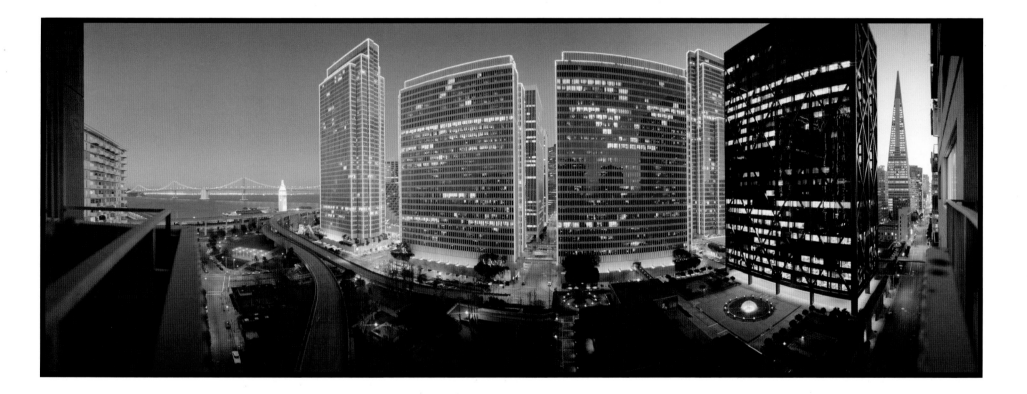

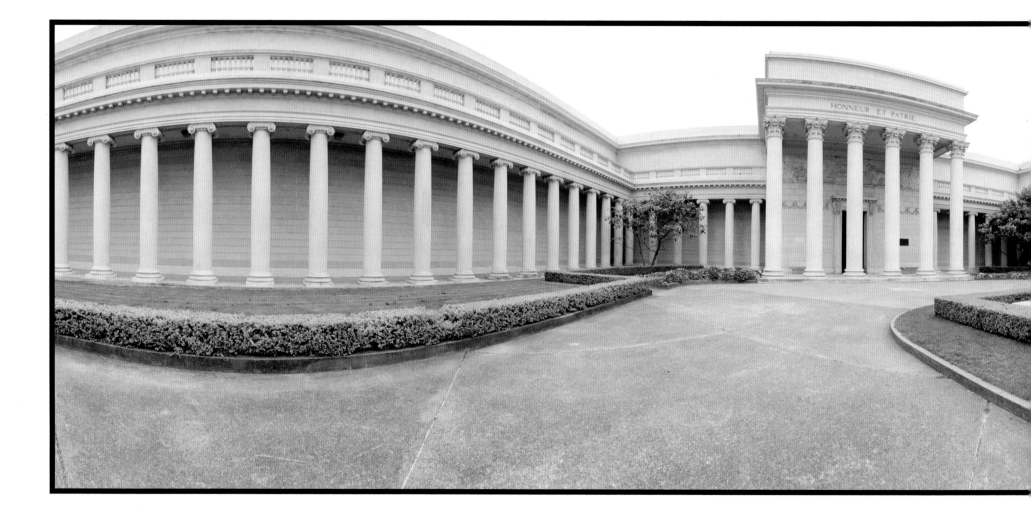

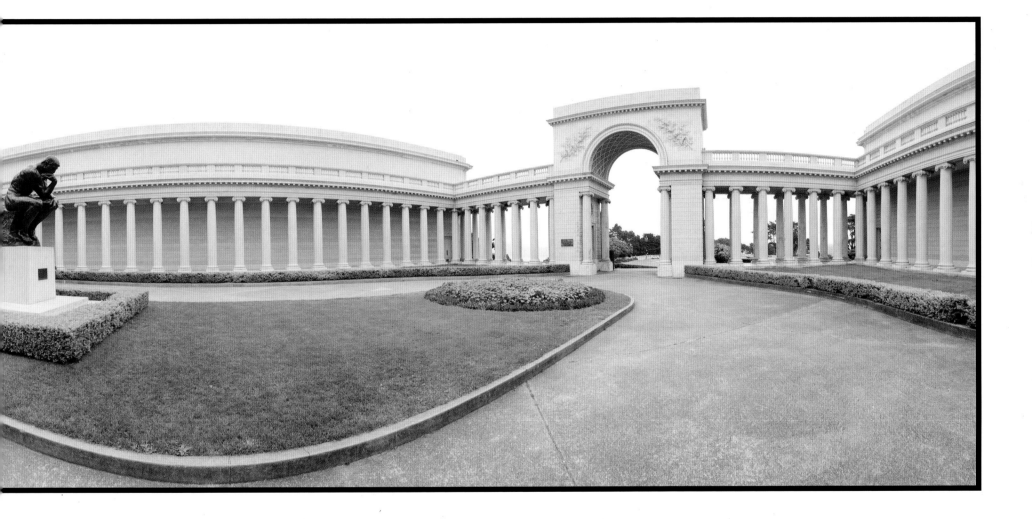

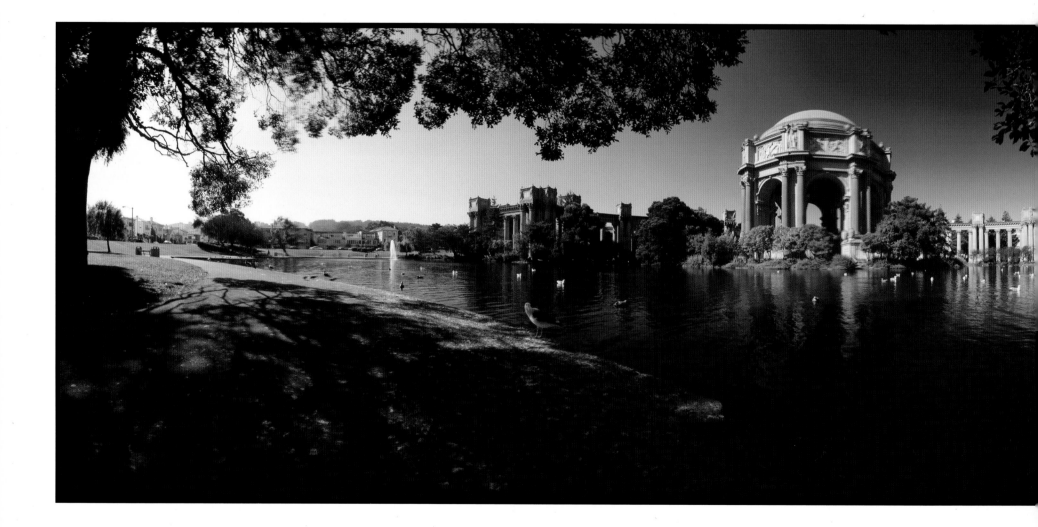

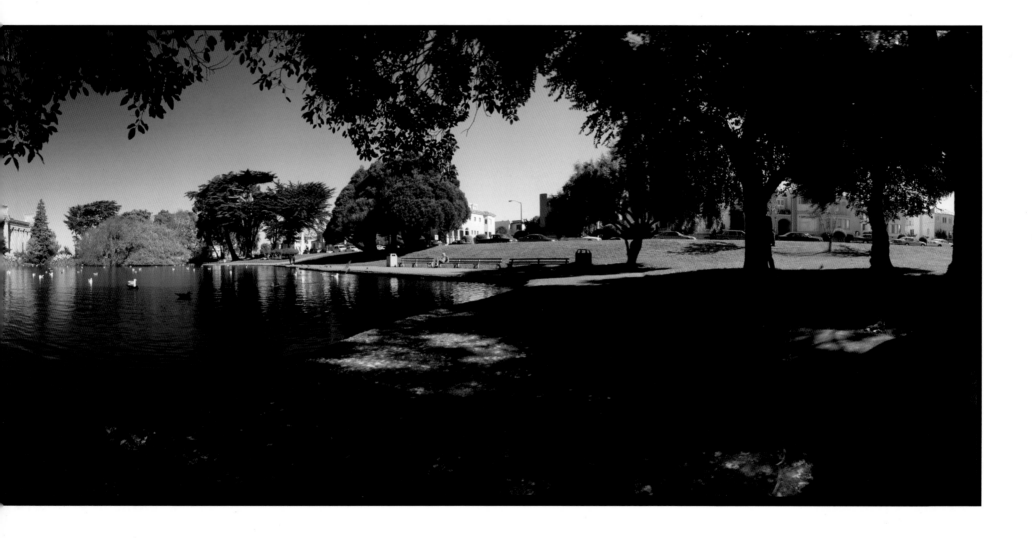

Index

Page 3 Gene's VW, Grant and Green early 1960s
Page 4 (a) The Enchanted Hill, 1984 (b) Gene's plane, about 1967
Page 5 (a) San Francisco Aerial, 1960s, (b) Car Accident, Utah, mid 1940s , (c) WWII POWs in Utah, about 1943
Page 6 (a) Pin-up photo, about 1944 (b) Gene and cameras, 1980
Page 7 (a) Experimental, 1950s (b) José Jiménez Album Cover, mid 1960s (c) 360º Hulcherama, about 1984
Page 8 (a) Model, 1960s (b) Wedding Photo, 1960s
Page 9 (a) Salvation Army at Christmas, 1953 (b) Liz, 1970 (c) Eight Moons Over Coit Tower 1967
Page 10 Embarcadero Buildings, 1981
Page 11 Key to San Francisco
Page 12 Port of San Francisco 1953
Page 13 View of Ferry Building from Commercial Street 1965
Page 14 China Town early 1960s
Page 15 (a) Telegraph Hill (b) Grant Avenue - 1960s
Page 16 Little Girl in Union Square 1954
Page 17 Two Girls in Union Square 1955
Page 18 City Hall, 1960s
Page 19 Washington Street View of Pyramid, 1972
Page 20 Powell and Market 1960s
Page 21 Powell and Market 1960s
Page 22 California and Grant, late 1950s
Page 23 California and Powell, late 1950s
Page 24 North Beach Barber Shop, 1960
Page 25 Co-Existence Bagel Shop, 1959
Page 26 Café Trieste, 1959
Page 27 St. Patrick's Day at Buena Vista, 1953
Page 28 The Village KSFO Event, early, 1960s
Page 29 The Village KSFO Event, early, 1960s
Page 30 Celebrities Out for the Evening, 1960s
Page 31 Grant Avenue Fair, mid 1960s
Page 32 Telegraph Hill, 1958
Page 33 Coit Tower, late 1950s
Page 34 Eight Moons Over Coit Tower, 1967
Page 35 (a) Coit Tower and Moons, 1967 (b) Coit Tower from the Fox Plaza (c) Moon Over Coit Tower, 1967 (d) Coit Tower from Montgomery Street, 1969
Page 36 Coit Tower from the Golden Gateway, 1990
Page 37 Gerke Alley, 1950s

Page 38 (a) Tracks, 1955 (b) Underside View of Golden Gate Bridge, 1954
Page 39 (a) City Hall Rotunda, 1950s (b) Fisherman's Wharf, 1950s
Page 40 Experimental photography, mid 1970s
Page 41 (a) The Balclutha, 1953 hi (b) Embarcadero Buildings, 1982
Page 42 Experimental, 1956
Page 43 Car, 1956
Page 44 Old Fort Point, 1958
Page 45 View of the Bay Bridge from the Ferry, 1956
Page 46 Fort Point and the Golden Gate in Fog, 1960
Page 47 Golden Gate Bridge with Old Cars, mid 1950s
Page 48 Sun Rise Over the Bay Bridge, 1971
Page 49 Fog and Bridge, 1972
Page 50 (a) Embarcadero from Alta Street, mid 1950s (b) Alta Street mid 1950s
Page 51 View from Russian Hill, early 1960s
Page 52 Aerial view, 1972
Page 53 (a) Embarcadero, mid 1960s (b) Embarcadero Photo Supply Shop, mid 1960s
Page 54-55 280º of San Francisco, early 1960s
Page 56-57 View from the Top of the Mark, early 1980s
Page 58 Telegraph Hill, mid 1960s
Page 59 View of Pacific Heights
Page 60 Bay Bridge from Yerba Buena
Page 61 Candlestick Park, 1960
Page 62 Ferry Buildings, 1951
Page 63 California Street, 1970s
Page 64 North Beach Alley
Page 65 China Town, Grant Avenue, 1960s
Page 66 Montgomery and Green, 1960s
Page 67 Montgomery and Green, 1980s
Page 68 Montgomery and Post Street, mid 1950s
Page 69 Iacopi's Meat Market, 1950s
Page 70 Palace of the Legion of Honor, 1962
Page 71 Lion Guard at Palace of the Legion of Honor, 1962
Page 72 View of Embarcadero from Telegraph Hill, 1950s
Page 73 Washington Square, late 1950s
Page 74 Mercy Madonna, 1963
Page 75 United Way Photo Shoot at St. Mary's Help Hospital
Page 76 Salvation Army at Christmas, 1953
Page 77 Nude and Umbrella, 1969

Page 78 KSFO, 1962
Page 79 (a) KSFO (b) Al "Jazzbeau" Collins, 1962
Page 80 KQED, mid 1960s
Page 81 KGO TV, Girl Scouts and Boy Scouts, mid 1960s
Page 82 4-up Model Shots, 1960s
Page 83 Model, 1960s
Page 84 (a) Commercial Interior, 1960s (b) Ladies Having Tea late 1960s
Page 85 Commercial Interior, 1960s (b) Apartment, 1971
Page 86 Gene and friends, about 1966
Page 87 Alta and Montgomery Street, late 1960s
Page 88 Aerial View, 1972
Page 89 Aerial View, 1972
Page 90 View from Russian Hill, about 1957
Page 91 Fog and City Scene (from Coit Tower), 1960
Page 92 Mother and Daughter Crossing Street, 1960s
Page 93 Jim Beam Cable Car, 1960s
Page 94 Fisherman's Wharf Scene, 1960s
Page 95 San Francisco International Airport, 1960s
Page 96 Embarcaderos, (a) 1972, (b) late 1973
Page 97 Aerial Embarcaderos, 1972
Page 98 (a) The Last Ferry, 1953 (b) Arthur "Pops" Fiedler on the Last Ferry, 1953
Page 99 The Last Ferry, 1953
Page 100 The Holiday Inn, 1970s
Page 101 Palace of Fine Arts, 1960s
Page 102 City Hall, 1970
Page 103 St. Patrick's Day, Embarcadero, 1970s
Page 104 Lamp Post, from Filbert and Montgomery Street, 1959
Page 105 Bay Bridge, 1980s
Page 106 Cable Car, 1976
Page 107 Embarcadero, Christmas, 1989
Page 108-109 360º Palace of the Legion of Honor, 1990s
Page 110-111 360º Palace of Fine Arts, 1993